CAPE TOWN

GERALD HOBERMAN

CAPE TOWN

GERALD HOBERMAN

PHOTOGRAPHS IN CELEBRATION OF

'THE FAIREST CAPE WE SAW IN THE WHOLE CIRCUMFERENCE OF THE EARTH'
SIR FRANCIS DRAKE 1580

TEXT BY ROELIEN THERON

THE GERALD & MARC HOBERMAN COLLECTION

CAPE TOWN • LONDON • NEW YORK

For Hazel, Richard, Joanne and Marc

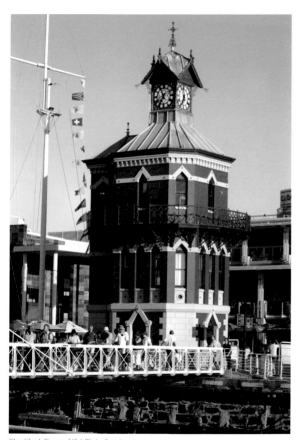

The Clock Tower, *V&A Waterfront*

CONTENTS

Acknowledgements 7

Map of Cape Town 8

Introduction 9

Cape Town 10

Select Bibliography 243

Index 245

Concept, photography, design and production control: Gerald Hoberman
Reproduction: Marc Hoberman
Text: Roelien Theron
Layout: Jenine Skinner
Indexer: Joy Clack
Cartographer: Peter Slingsby

www.hobermancollection.com

ISBN: 978-191993949-0 ISBN: 1-919939-49-0

Cape Town is published by The Gerald & Marc Hoberman Collection (Pty) Ltd
Reg. No. 99/00167/07, PO Box 60044, Victoria Junction, 8005, Cape Town, South Africa
Telephone: 27-21-419 6657/419 2210 Fax: 27-21-418 5987 e-mail: office@hobermancollection.com

International marketing, corporate sales and picture library

United Kingdom, Republic of Ireland, Europe
Hoberman Collection (UK)
250 Kings Road, London, SW3 5UE
Telephone: 0207 352 1315 Fax: 0207 681 0064
e-mail: uksales@hobermancollection.com

United States of America, Canada, Asia
Hoberman Collection (USA), Inc. / Una Press, Inc.
PO Box 880206, Boca Raton, FL 33488, USA
Telephone: (561) 542 1141
e-mail: hobcolus@bellsouth.net

**For copies of this book printed with your company's logo and corporate message contact
The Gerald & Marc Hoberman Collection. For international requests contact Hoberman Collection UK.**

Other titles in this series by The Gerald & Marc Hoberman Collection

Donald Greig
Exclusive Safari Lodges of South Africa
London
Namibia

South Africa
South Africa's Winelands of the Cape
Venice
Wildlife of Africa

Agents and distributors

Namibia	*South Africa*	*London*	*United Kingdom, Europe and Ear East:*	*United States of America, Canada*
Projects & Promotions cc	Hoberman Collection	DJ Segrue Ltd	John Rule Sales & Marketing	Perseus Distribution
PO Box 656	6 Victoria Junction	7c Bourne Road	40 Voltaire Road,	387 Park Avenue South
Omaruru	Prestwich Street, Green Point	Bushey, Hertfordshire	London SW4 6DH	New York
Tel: +264 64 571 376	Tel: +27 (0)21 419 6657	WD23 3NH	Tel: 020 7498 0115	NY 10016
Fax: +264 64 571 379	Fax: +27 (0)21 425 4410	Tel: (0)7976 273 225	email: johnrule@johnrule.co.uk	Tel: (212) 340 8100
e-mail: proprom@iafrica.com.na	e-mail: office@hobermancollection.com	Fax: (0)20 8421 9577		Fax: (212) 340 8195
		e-mail: sales@djsegrue.co.uk		

Printed in Singapore

ACKNOWLEDGEMENTS

*I*n a world too often prepared to 'cut corners', it is heartening and uplifting to find kindred spirits prepared to go that extra mile beyond commercialism in the pursuit of excellence. The 'A' team I have been privileged to work with has proved to be an invaluable part of the equation in my quest for perfection.

The images have been scanned with uncompromising dedication by my son Marc, using the latest cutting-edge, state-of-the-art technology available. It has been meticulously printed by some of the best craftsmen I have had the pleasure to work with. The finest paper manufactured from ecologically sustainable forests has been used.

I would like to thank the following people who assisted by sharing their knowledge about Cape Town. This book is a richer offering because of them.

GERALD HOBERMAN

AB Barnes
Stefan Braun, Richard Bray
(ARABELLA COUNTRY ESTATE AND GOLF COURSE)
Heinrich Brümfield (GROOT CONSTANTIA)
Mike Bruton, Elaine McDonald, Lex Fearnhead
(TWO OCEANS AQUARIUM)
Fuad Cottle
John Davis
Patricia Davison, Lindsay Hooper (SOUTH AFRICAN MUSEUM)
Deon Dreyer, Eugenie Livingstone, Adam Mecinski
(TABLE MOUNTAIN NATIONAL PARK)
Leana du Preez, Marlicet Schuurman
(THE CASTLE OF GOOD HOPE)
Stephan du Toit (DIEP DONNE)
Noor Ebrahim, Linda Fortune (DISTRICT SIX MUSEUM)
Greg Erasmus
Clarence Ford (MANENBERG JAZZ CAFÉ)
Shereen Habib (TANABARU TOURS)

Stuart Harris
Sabine Lehman, Rianda Williams (TABLE MOUNTAIN AERIAL CABLEWAY COMPANY)
Linda Jack (WESTERN PROVINCE RUGBY FOOTBALL ASSOCIATION)
Natasha Jason (VICTORIA AND ALFRED WATERFRONT)
Aly Khan (OTHERSIDE TOURS)
Owen Kinahan (JOSEPHINE MILL)
Brian Kirsch
Howard Langley (SOUTH AFRICAN NATIONAL PARKS BOARD)
Robert Macdonald, Luigi Aiello (SPORT HELICOPTERS)
Yvette Maniengisa
Marilyn Martin, Hayden Proud
(SOUTH AFRICAN NATIONAL GALLERY)
Lalou Meltzer (WILLIAM FEHR COLLECTION)
Dan Mgushelwana
The Osman family (OSMAN'S STORE)
Sheryl Ozinsky
David Rhind

Veronica Rhoda (PUBLIC RELATIONS, PARLIAMENT)
Dr Peter Ryan (PERCY FITZPATRICK INSTITUTE OF AFRICAN ORNITHOLOGY, UNIVERSITY OF CAPE TOWN)
Laurie Rose-Innes
Topsy Sakayi
Bruce See (TABLWALKER' WATERFRONT BOAT TRIPS)
Phindiwe Siwela
Dr Roger Smith (SOUTH AFRICAN MUSEUM)
Southern Right Charters, Hermanus
Jean-Pierre Titch, Camillo Lombard, Lionel Beukes,
Denver Furness, Danny Smith
(BAND MEMBERS, OUT OF TOWN)
Anista van Huyssteen, Annemarie Greyling
(SOUTH AFRICAN CULTURAL HISTORY MUSEUM)
John Winter, Dr John Rourke, Christien Malan, Hermine
Marent (NATIONAL BOTANICAL INSTITUTE)

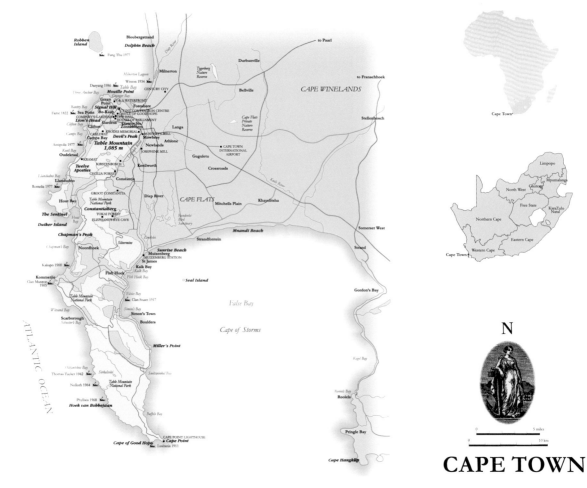

CAPE TOWN

INTRODUCTION

Cape Town is unrivalled for its scenic splendour. This scintillating jewel at the southern tip of the African continent, with its rich flora and fauna and vibrant cultural fusion, is a very special place.

The city is set in an amphitheatre of spectacular mountains. Flat-topped Table Mountain, with its world-famous cableway, is flanked by Devil's Peak, Lion's Head and Signal Hill; on the Atlantic seaboard the majestic Twelve Apostles stand sentinel. Nearby is the towering, awesome splendour of Chapman's Peak. At the southernmost tip of the Cape Peninsula, an experience of breathtaking exhilaration awaits as one views Cape Point with its craggy finger-like promontory, where the world's highest cliffs are lashed by wild currents and treacherous seas. From here in the direction of Cape Agulhas, the Indian and Atlantic Oceans meet. The Cape Peninsula is fringed with pristine white sandy beaches; it has dramatic sunsets and a Mediterranean climate, fanned by gentle ocean breezes. These breezes contribute to the success of the renowned vineyards along the picturesque wine route. On occasion a howling wind changes the mood as the south-easter, affectionately known as the Cape Doctor, delivers fresh clean air.

The Cape Peninsula's inhabitants, estimated to be some four million people and growing rapidly, are multi-ethnic and of a rich cultural diversity.

Started in 1990 and still growing is Cape Town's Victoria & Alfred Waterfront. It is a historic dockland, still ever active and integrated with converted warehouses. Lively restaurants, cafés, hotels, shopping malls, cinemas and theatres abound. There is an aquarium and a helipad as well as craft markets, curio shops, a conference centre, a university campus, a marina and luxury apartments. Here the citizens of Cape Town enjoy converging and mingling with visitors from around the world in a dockside atmosphere. Small wonder that Cape Town is regarded as a premier tourist destination!

I consider myself most fortunate to have been born and brought up in the 'Mother City'. Although I have travelled widely, I have lived here for most of my life, yet each time I return I feel a twinge of nostalgia when I see Table Mountain again. It has been a great pleasure to produce this book and, through the medium of photography, present to you the quintessence of Cape Town as I see it. To cover every aspect is of course beyond the scope of any one volume.

I look forward to sharing these selected 'magic moments' with you and preserving them for posterity, as a memento, a record and a celebration of life in Cape Town at the dawn of the twenty-first century.

Gerald Hoberman

GERALD HOBERMAN
Cape Town

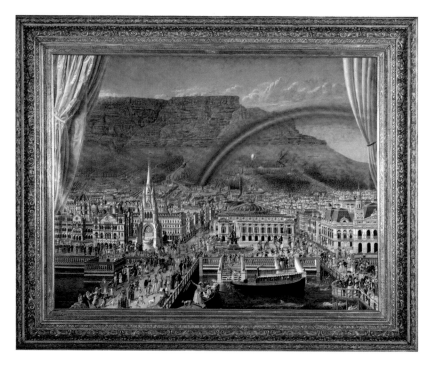

SOUTH AFRICAN NATIONAL GALLERY, CAPE TOWN

James Ford's *HOLIDAY TIME IN CAPE TOWN IN THE TWENTIETH CENTURY*
in honour of the expected arrival of the Governor-General of *UNITED* South Africa
PAINTED 1891–1899 (oil on canvas)

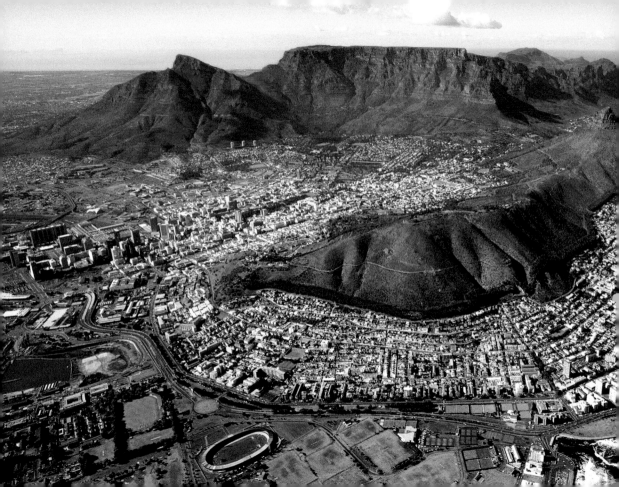

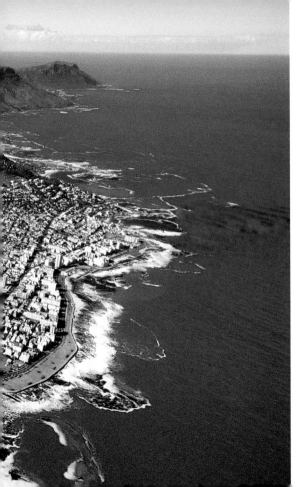

THE FAIREST CAPE

We ranne hard aboard the cape, finding report of the Portugals to be most false, who afferme that it is the most dangerous cape of the world, never without intolerable storms and present dangers to travellers which come neare the same. This cape is the most stately thing and the fairest cape we saw in the whole circumference of the earth.

From the journal of Sir Francis Drake, 1580.

13

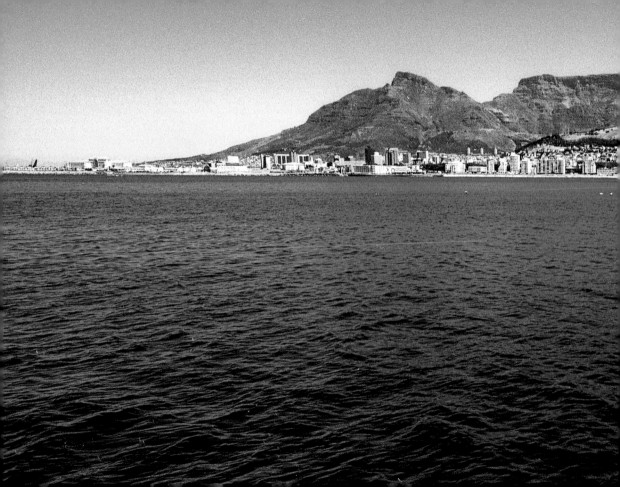

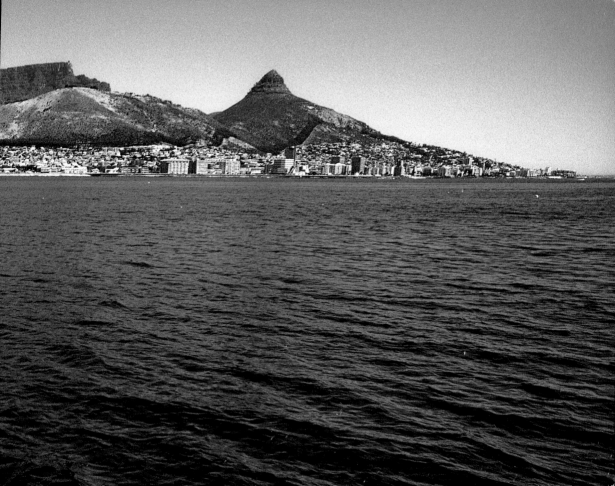

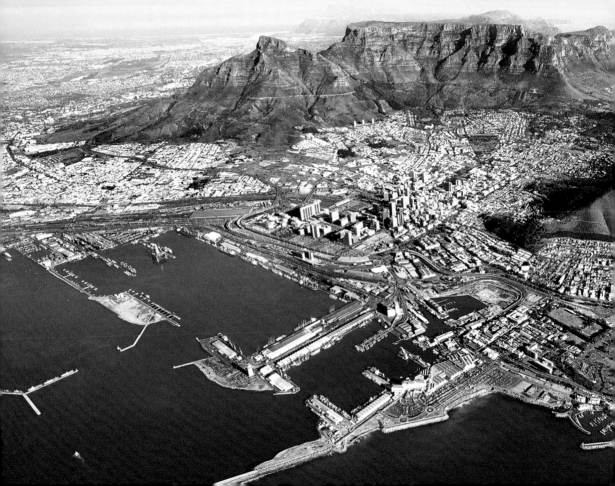

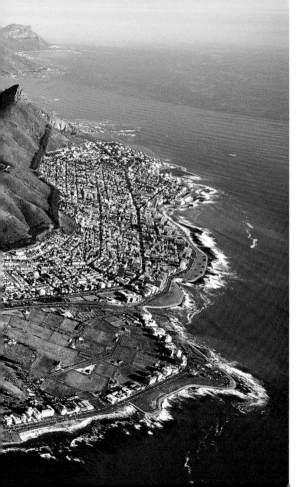

HARBOUR CONSTRUCTION

Plans for the development of a harbour in Table Bay were first drawn up in 1854 by the engineer Sir John Goode, famous for his design of the harbour in Portland in Dorset. Building of the breakwater began soon afterwards, and, in 1860, Prince Alfred, second son of Queen Victoria, inaugurated its construction by tipping the first load of rocks. Ten years later he would open the first harbour basin, the Alfred Basin. An increase in shipping, caused by industrialisation, led to the expansion of the docks, and a second basin, the Victoria Basin, was built piecemeal from 1870 to 1905. In both cases local convict labour was used for the construction. The advent of larger ships and increased traffic during the war years necessitated the building of a larger and deeper dock. The Duncan dock, completed in 1944, was built nearly a kilometre out to sea, creating a 200-ha zone of reclaimed land which wrenched the docklands from the city – a separation that came to an end almost 50 years later with the timely redevelopment of the harbour and the formation of the V&A Waterfront as a leisure, tourist and residential centre.

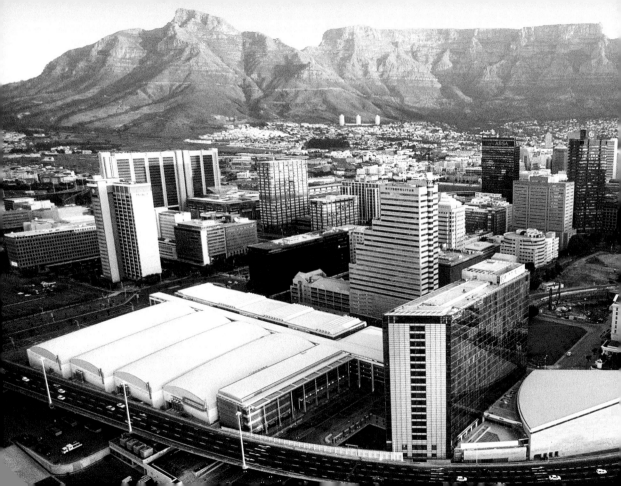

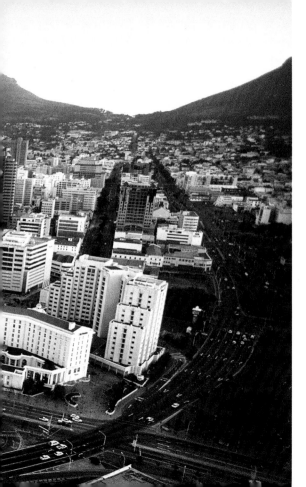

CAPE TOWN INTERNATIONAL CONVENTION CENTRE

When city administrators decided that the time had come to construct the one vital piece of missing tourism infrastructure in Cape Town, a team of internationally experienced architects, engineers and designers rose to the challenge of creating a state-of-the-art facility that could compete with the best in the world. Completed in 2003, the Cape Town International Convention Centre is situated in the heart of one of the world's most beautiful and popular cities and is within easy reach of most of its famous tourist attractions. The convention centre has two auditoriums, 33 meeting rooms, a roof terrace room with a view, and 10,000 m² of uninterrupted exhibition space, and can host 10,000 guests.

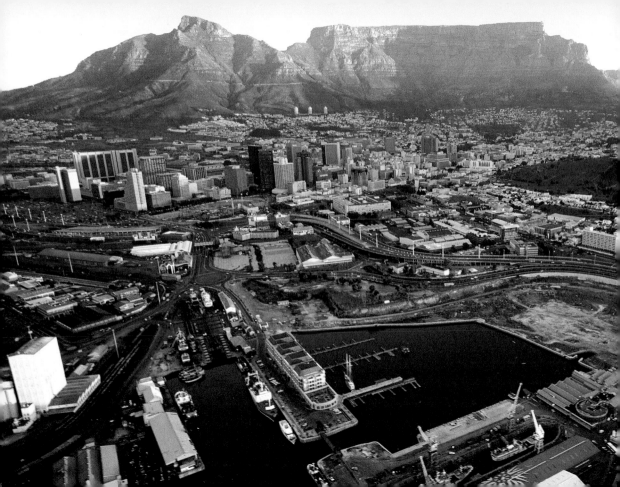

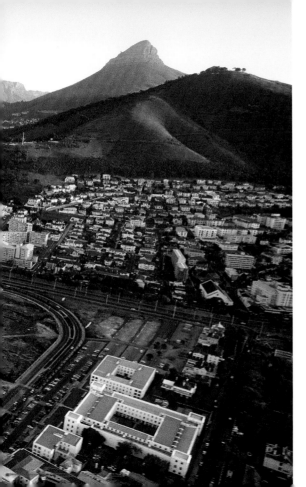

THE V&A WATERFRONT

What some saw as simply a working harbour, others saw as one of the most romantic settings in the world. When in the late 1980s port authorities decided to turn their loss-making asset into a going concern, little did they know that their visionary plan would become an internationally acclaimed success story. Spanning 123 ha of land and water areas and representing an almost R2-billion investment in the city of Cape Town, the redevelopment of the once derelict harbour into the V&A Waterfront has been described as bold and dramatic. Today it is a premier tourist destination, attracting close to 2 million visitors per year.

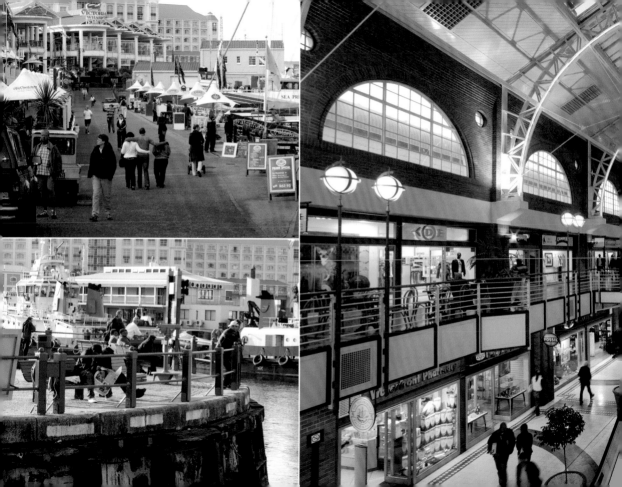

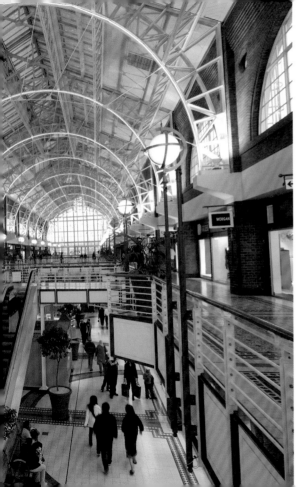

ON THE WATERFRONT

At the water's edge lies the V&A Waterfront, a vibrant combination of contemporary urban design and revamped Victorian dockland. Rescued from a state of disrepair, after many years of negotiation, the buildings of the historic Victoria and Alfred Basins were converted into wharfside malls, hotels, eateries, taverns and markets to provide a unique, all-week shopping and entertainment experience. Living side-by-side with the old are the new retail complexes, Two Oceans Aquarium and residential developments, intelligently designed to complement the Victorian character of the harbour. Set amidst the hurly-burly of a working port, the V&A Waterfront has brought new life to Table Bay harbour.

23

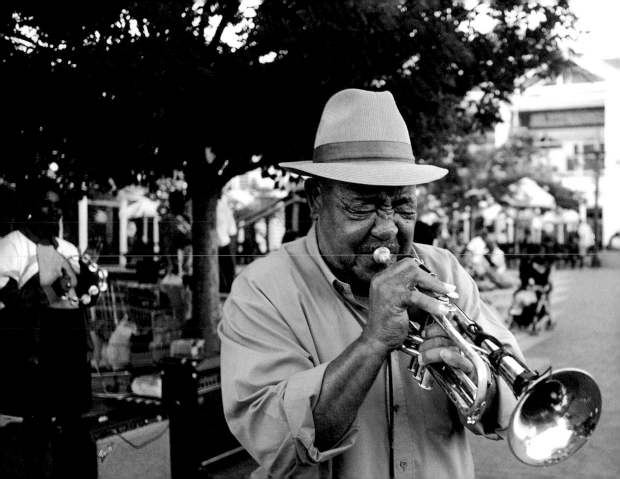

JAZZ AT THE WATERFRONT

One of Cape Town's premier shopping destinations, the V&A Waterfront is also one of its main entertainment centres. During the summer months street musicians entertain visitors with their own brand of Cape jazz, a main ingredient in the musical mix offered at the Waterfront. The year starts off with the annual four-day Jazzathon, which showcases some of the city's finest talents, and ends with the Sunsetter Festival, during which the cream of local musicians perform a wide range of music styles, from jazz and blues to kwaito and acoustic rock. In addition, several Waterfront restaurants regularly feature some of the country's top jazz musicians.

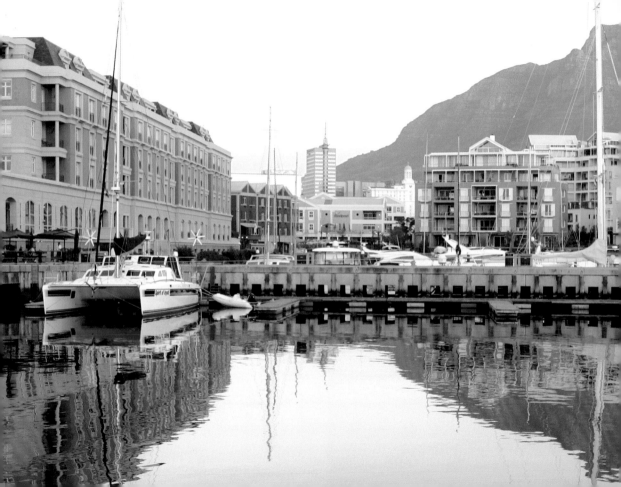

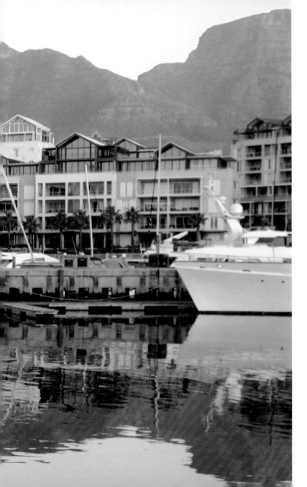

WATERFRONT VILLAGE

Overlooking the V&A Waterfront Marina, Waterfront Village offers holidaymakers, travellers and business delegates a luxurious home away from home. The collection of self-catering and serviced apartments, managed by Village & Life, combines all the comforts of a first-class hotel with the spontaneity and freedom of home.

More than eighty stylishly furnished apartments and penthouses, with one, two or three bedrooms, are on offer. The apartments vary in size from 65 m² to 300 m². Stays can range from one night to several months.

A full concierge service is available to take care of visitors' every whim and fancy. The service includes making restaurant bookings, arranging sight-seeing tours and helicopter trips and even chartering boats.

Discerning visitors and high-profile celebrities wishing to entertain or have business meetings in the privacy of their apartments can order their very own butler, executive chef and waiters for the occasion.

The Waterfront Village is conveniently situated close to top-flight restaurants, bars and other amenities.

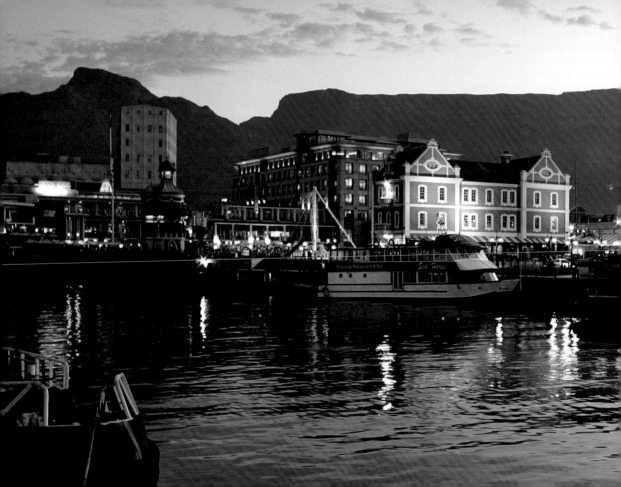

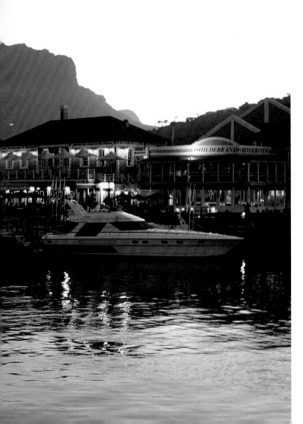

THE OLD PORT CAPTAIN'S OFFICE BUILDING

The Old Port Captain's Office Building, now handsomely restored, was built in 1904, when the harbour was expanding rapidly and the management of the docklands became an increasingly sophisticated endeavour. The gabled building stands next to the 'Cut' at the entrance to the Alfred Basin, and replaced the nearby octagonal, Gothic-style Clock Tower built in 1882 as the first Port Captain's Office and used as a lookout by shipping controllers and berthing staff. The Clock Tower housed the only tide gauge on the coast at the time. The oldest building on the pierhead is the Harbour Cafe, opened in 1903 as a public tearoom. The building continues to function as a restaurant.

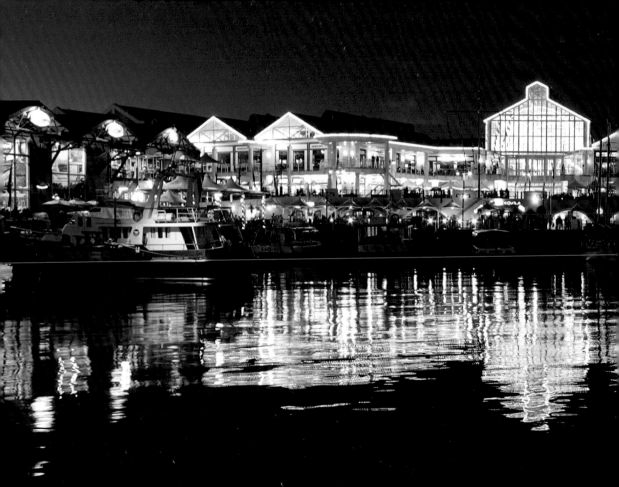

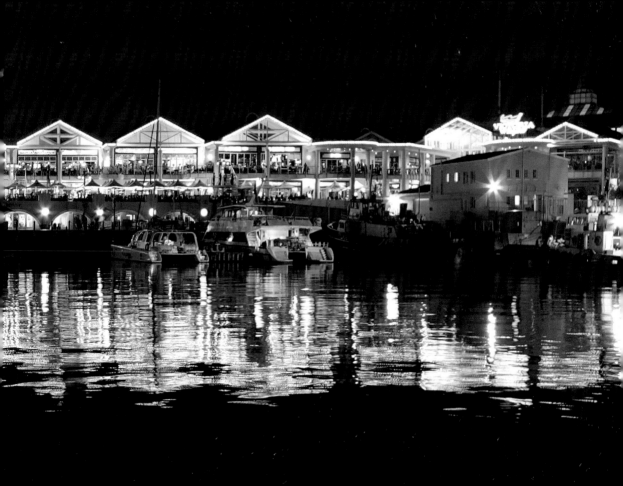

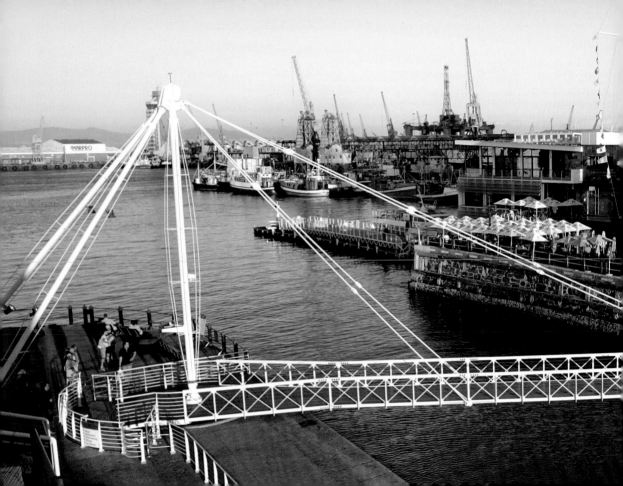

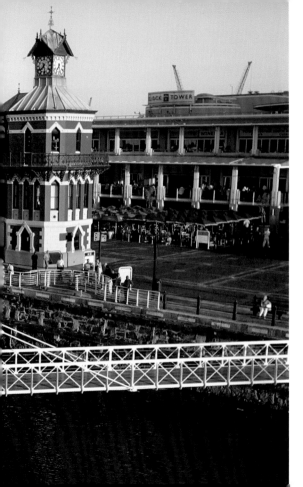

THE CLOCK TOWER

This magnificent Victorian-era octagonal clock tower painted a colour similar to that of its original brickwork is situated on Clock Tower Square. An icon of the old Cape Town docks and a symbol of the V&A Waterfront, it stands sentinel over the comings and goings of the busy harbour – just as it has ever since its completion in 1882 as the first port captain's office. Since then it has served duty as a reading room for visiting ship captains and as an office building for fishing giant, Irvin & Johnson. The building was restored in 1997. The mechanism of its elegant clock was made in Edinburgh, Scotland, by J.A. Richie & Son in 1883. The clock was restored in 1976. On the ground floor of the tower is a tide gauge which, when operational, allowed passing vessels to determine the ebb and flow of the harbour waters. The wall of the stairwell leading to the second floor is graced by a painting of the Madonna and child. The second floor features a mirror room, which gave the port captain 'eyes at the back of his head', thus enabling him to have a view of all activities in the docks. Today this room houses a restaurant serving light meals, which is run by famous restaurateur Peter Veldsman of the nearby Emily's Restaurant. An elegant swing-bridge links the Clock Tower Precinct with the Pierhead.

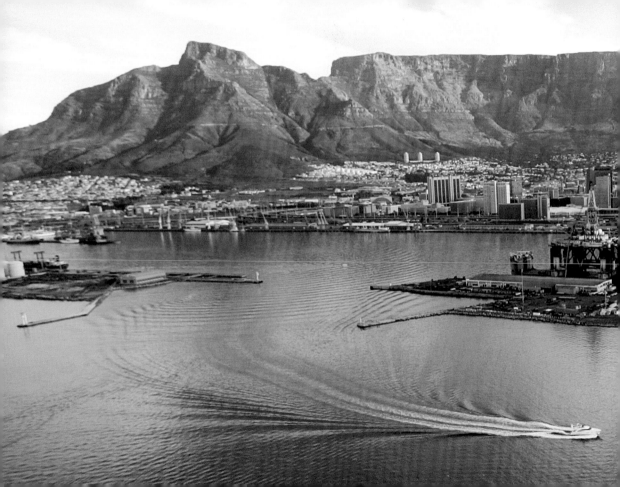

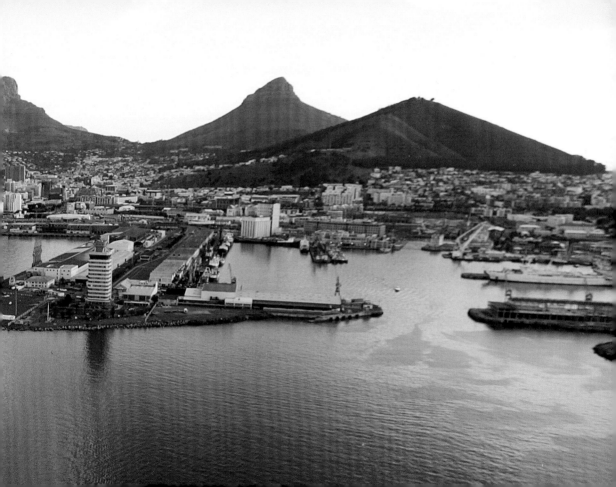

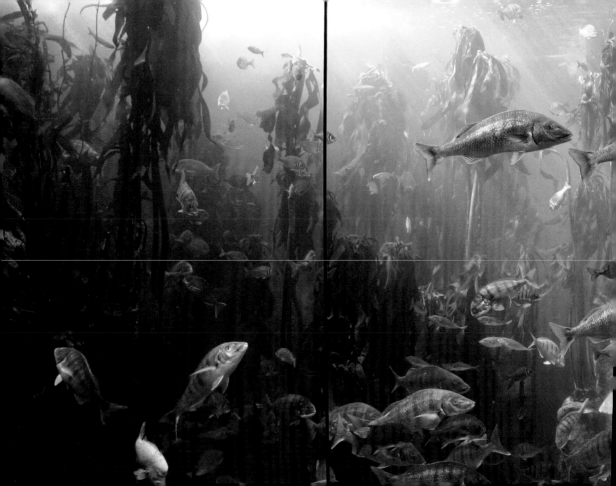

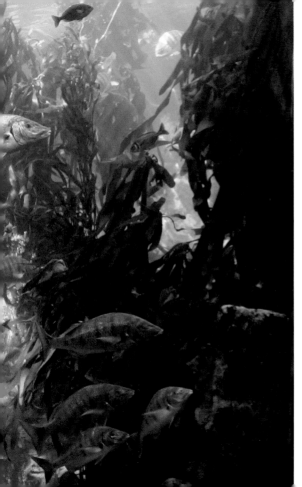

TWO OCEANS AQUARIUM

The Two Oceans Aquarium at the V&A Waterfront is home to some 3,000 sea creatures, most of which come from the two oceans that meet at the southern tip of Africa – the Indian and the Atlantic. The Kelp Forest Exhibit is a popular exhibit and one of only two such displays in the world, the other being at Monterey Bay Aquarium in the United States of America. The 800,000-litre Kelp Forest Exhibit showcases the giant kelp forests that dominate the rocky shores off South Africa's west coast and the cold-water fish that populate them. This forest remains one of the aquarium's biggest draw-cards, and many visitors return time and time again to enjoy its beauty and tranquillity.

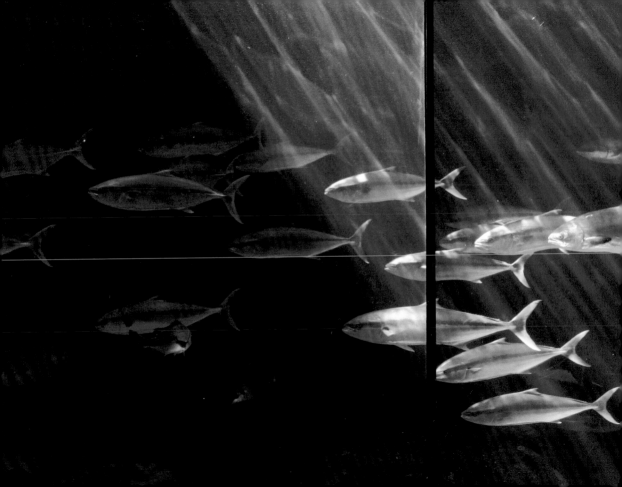

I&J PREDATOR EXHIBIT

Containing two million litres of seawater, the enormous 11-metre wide and 4-metre high I&J Predator Exhibit at the Two Oceans Aquarium provides a dramatic window on piscine life along South Africa's coast. Large ragged-tooth sharks patrol the waters of this exhibit while an assortment of predatory fish, graceful rays and a loggerhead turtle appear to swim effortlessly against the 1-knot current in the tank. Members of the public who desire a closer encounter with the aquarium's predators can sign up for a shark dive – as long they have a scuba-diving qualification.

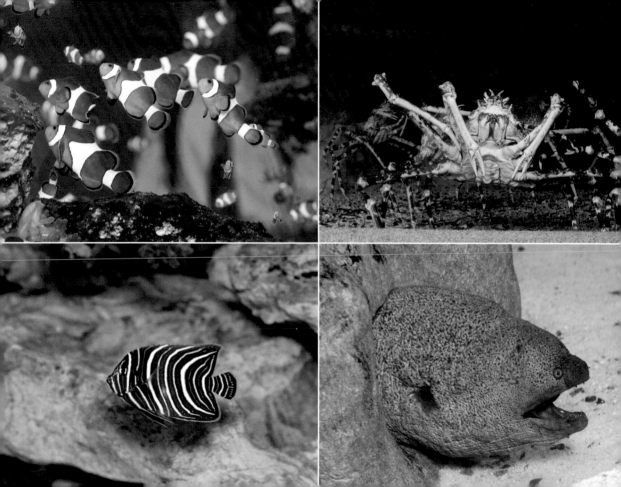

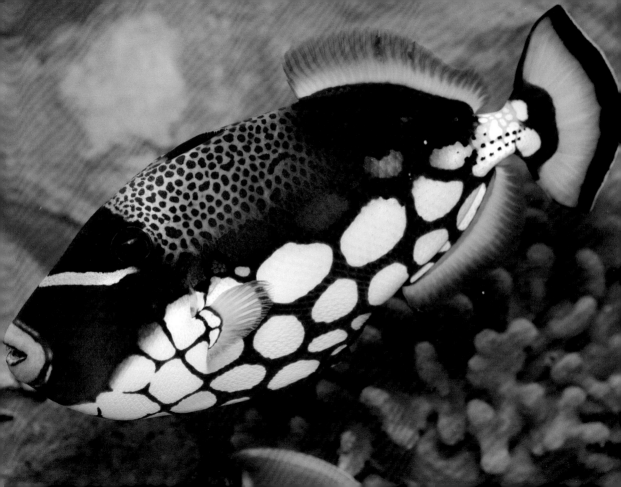

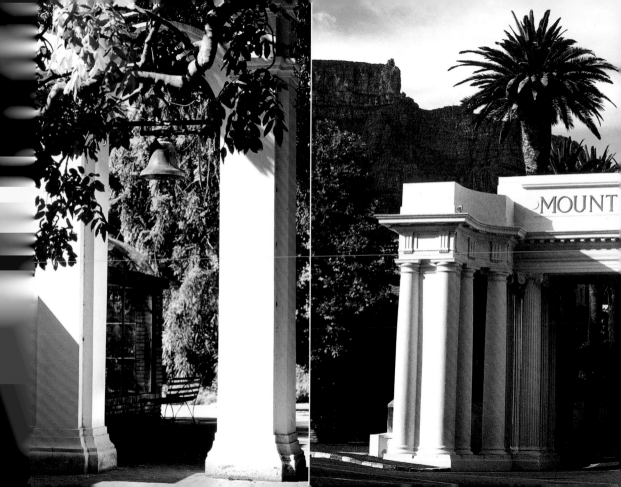

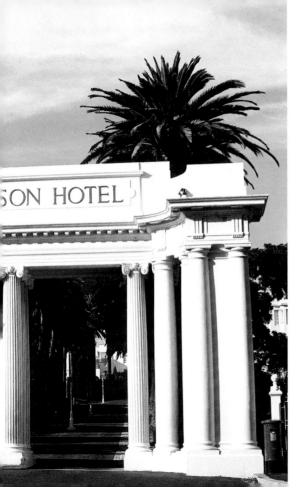

THE BELL TOWER

The bell tower, situated more or less in the centre of the Company's Garden next to the aviary, carries a bell cast in London in 1855. Although reminiscent of an old slave bell, this particular bell was used to announce the daily closing of the Company's Garden at sunset.

THE MOUNT NELSON

The Mount Nelson Hotel, with its neo-classical colonnade, stately avenue of palms and beloved pink exterior, was built in 1897, under the supervision of Herbert Baker. William Maude, an earlier owner of the property, had named it in honour of Lord Nelson's victory at the Battle of Trafalgar in 1804. During the South African War (1899–1902) the British established their headquarters there, as did some Transvaal mine-owners, preferring to run their businesses from the relatively peaceful Cape. Set in 7 acres of parkland, the Mount Nelson has entertained such famous guests as Winston Churchill, Rudyard Kipling and Arthur Conan Doyle.

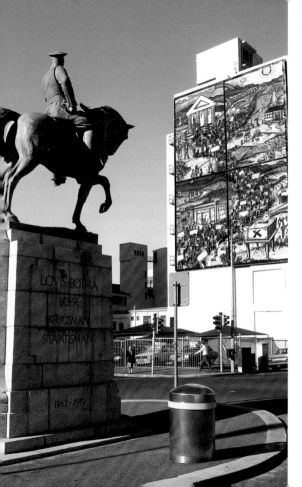

ONE PERSON, ONE VOTE

At the entrance to Parliament, in the bright sunshine of a new democracy, a mural captures the tale of a nation reborn. Its rendition of universal franchise stands in cheery contrast to the solitary military figure of General Louis Botha, the first prime minister of the Union of South Africa. Ironically, it was the Union constitution that laid the foundations of apartheid by denying most black South Africans political rights. General Botha now watches over one of the world's most memorable moments: the first all-race general election in South Africa on 27 April 1994, which led to the adoption of a new constitution and a Bill of Rights, granting all citizens equal status before the law, for the first time ever.

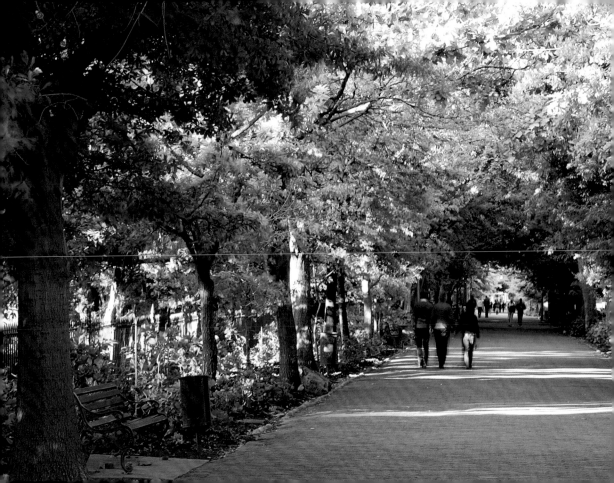

GOVERNMENT AVENUE

Leaves and branches entwine to form a canopy of shade along the oak-lined Government Avenue. The Avenue, linking Adderley Street with the city suburb of Gardens, bisects the Company's Garden, established by Jan van Riebeeck in 1652 to supply fresh produce to ships calling at the Cape. The Company's Garden was later turned into a botanical garden, planted with indigenous and exotic plants from as far afield as Australia, South America and the East Indies.

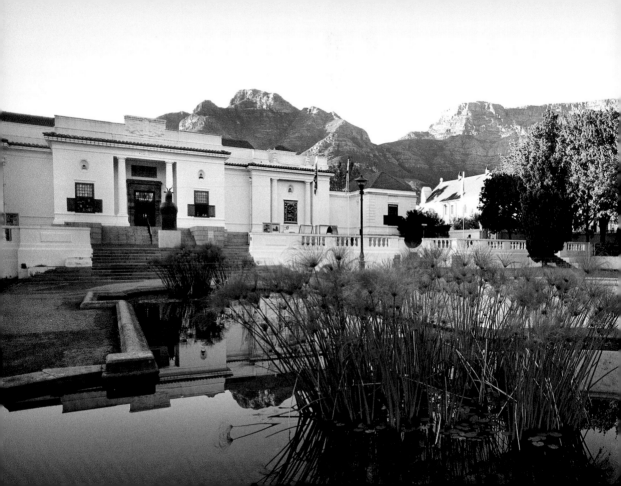

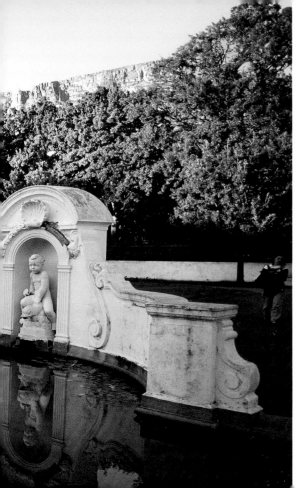

THE SOUTH AFRICAN
NATIONAL GALLERY

The 'boy on a dolphin' statue overlooks the fish pond in the Company's Garden. Next to the pond is the South African National Gallery, which had its beginnings in a bequest of 45 paintings in 1871 by Thomas Bayley. These were eventually housed in the spacious gallery built in 1930. The gallery's permanent collection contains British, French, Dutch and Flemish art. There is a fine collection of contemporary South African art, sculpture and crafts, representing the country's vibrant and diverse artistic heritage. The gallery is also involved in the repatriation of artefacts removed from the country in previous centuries.

51

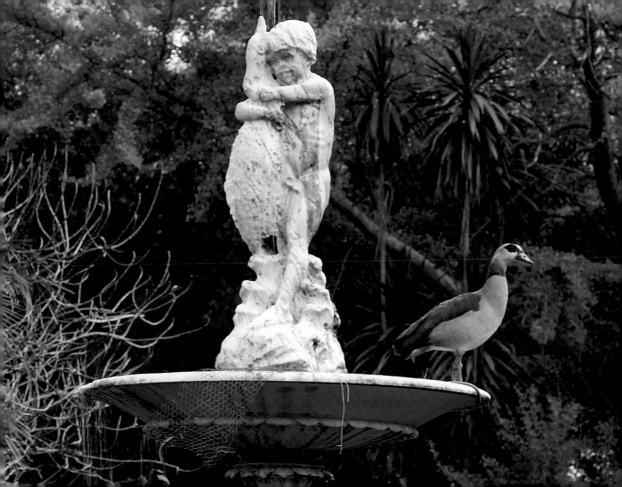

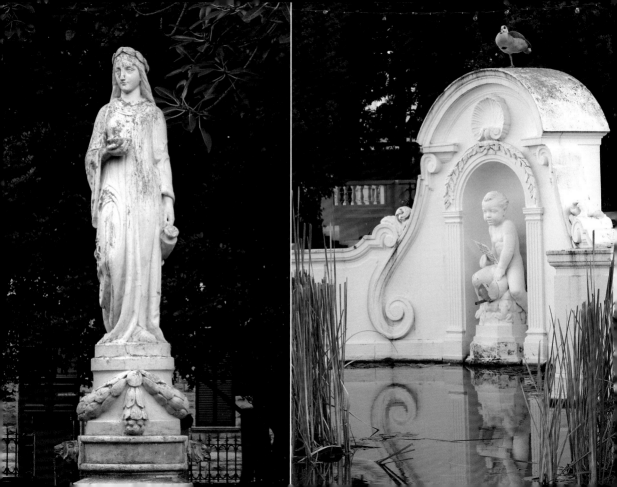

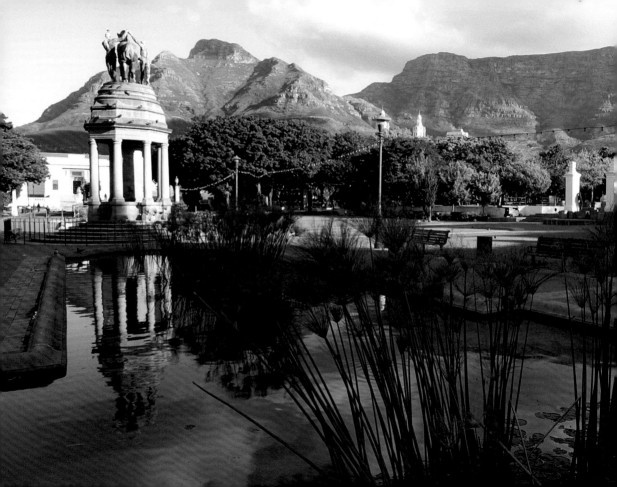

WAR MEMORIAL

A statue in the Company's Garden, to which the mountain provides a majestic counterpoint, commemorates all South Africans who died in the world wars of 1914–1918 and 1939–1945. The statue *Brotherhood* – a bronze group of a horse and two men – is a replica of the group surmounting the South African national memorial erected at Dellville Wood in France.

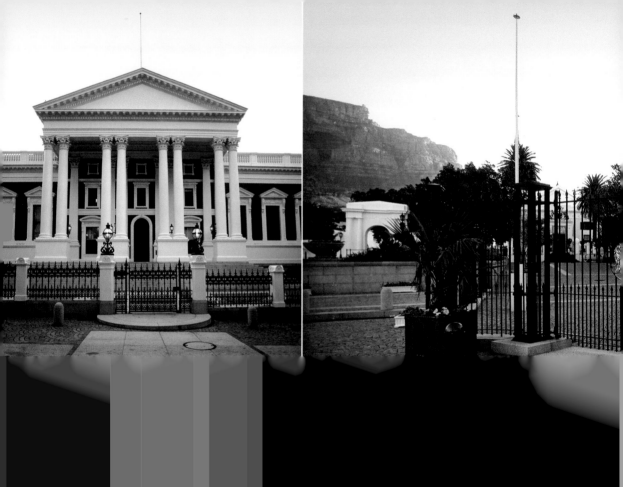

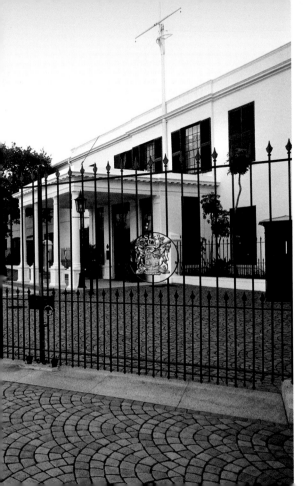

THE HOUSES OF PARLIAMENT

The need for a suitable parliamentary building arose soon after the Cape Colony was given partial self-government by the British in 1853. Although plans were prepared by 1860, the design of the Houses of Parliament was only put out to competition in 1874. The design of Charles Freeman, a young British-born architect in the service of the Department of Public Works, was awarded the first prize of 250 guineas, and Freeman was appointed resident architect. On 12 May 1875 a public holiday was declared and in an extravagant display of pomp and ceremony, the foundation stone was laid. Less than a year after the event Freeman was dismissed amidst accusations of defective foundations and misleading the selectors about the real cost of his design. At the same time the granite foundation stone, weighing about 3 tons, vanished. The project was given to another young architect, Harry Greaves, who submitted a less flamboyant version of Freeman's original design. The foundations were rebuilt and most of the materials for the building were imported from England. The building was completed in 1884 at a cost of £220,000, an astronomical amount at the time. The Houses of Parliament are situated in a leafy area at the top of Adderley Street.

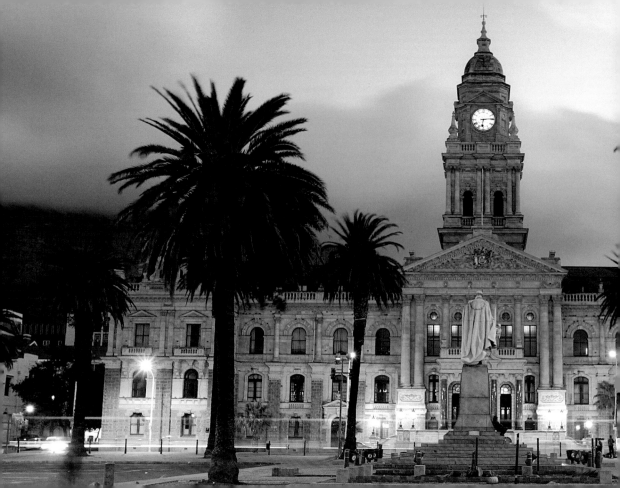

THE CITY HALL

The ornate, Italian-Renaissance-style City Hall, one of the last buildings of the Victorian architectural era, was completed in 1905. Symbolising the sandstone and granite composition of Table Mountain, the building is made of sandstone, imported from Bath, and has a granite base. The turret clock is half the size of the clock in St Stephen's Tower at the Houses of Parliament in London, and contains five bells. The carillon, which hangs just below the clock, contains 39 bells and was inaugurated in 1925. The City Hall replaced the Old Town House on Greenmarket Square as the seat of local government in Cape Town. Today, the city council occupies larger premises at the Civic Centre on the Foreshore. The City Hall in Darling Street still houses the Central Library, the Grand Hall, used for music concerts, the municipal courts and several other municipal offices. Across from the City Hall is the Grand Parade with its statue of Edward VII in coronation robes. An estimated 100,000 people gathered here on 11 February 1990 to hear released political prisoner and president-to-be Nelson Mandela give his first public address after spending 27 years in prison.

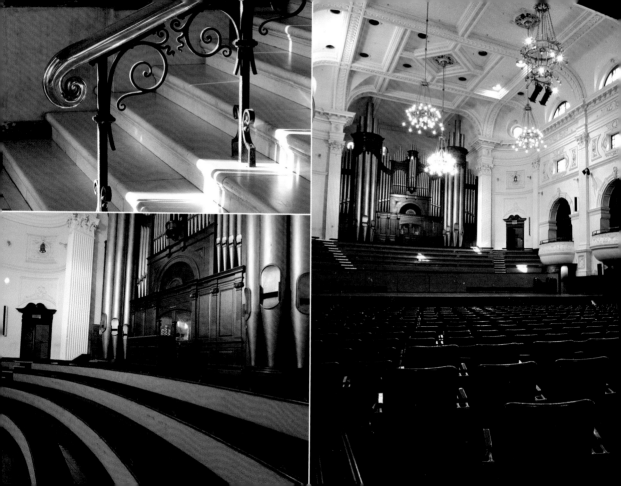

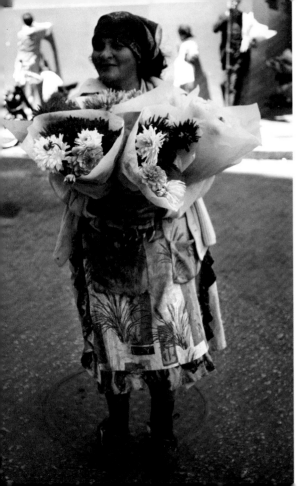

FLOWER SELLERS

The flower sellers of Adderley Street, with their bright and fragrant blooms, are one of Cape Town's oldest and most colourful institutions. They have survived many threats to turn them out of the city centre, and despite restrictive by-laws and fierce competition from nearby department stores, they continue to ply a trade begun by their ancestors over a century ago. As late as the 1920s indigenous flowers were still being plucked from the surrounding mountain slopes and the Cape Flats, until the Wild Flower Protection Society intervened to prohibit the practice. Many flower sellers also cultivated their own gardens on land owned or leased in the fertile Constantia valley and in Diep River. Today only cultivated flowers, purchased from surrounding farms or flown in from other parts of the country, are sold at Trafalgar Place in Adderley Street, the Parade, and street corners in and around the city.

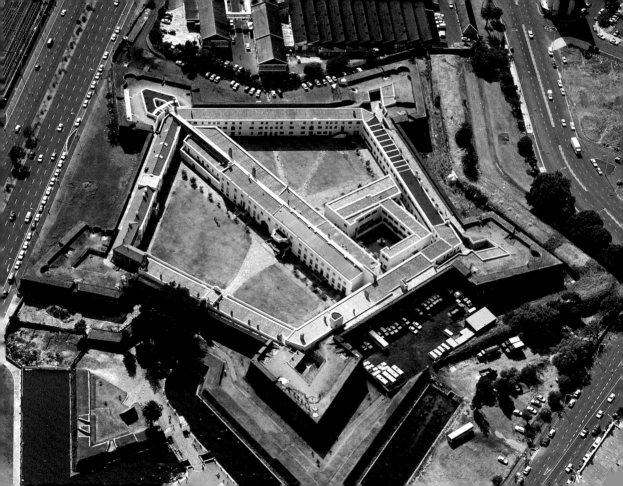

CAPE TOWN CASTLE

The original Castle of Cape Town was an earth fort commissioned by Jan van Riebeeck. The present Castle was built between 1665 and 1676, and is one of the oldest European structures in southern Africa. Its unusual pentagonal shape was pioneered by Sébastian de Vauban, Louis XIV's military engineer. The design became popular in defensive military architecture, and is the basis of the US Defense Department headquarters (the Pentagon) in Arlington, Virginia. The design of the bastions allowed the defenders to cover the adjacent walls as well as each opposite bastion, should its defenders fall.

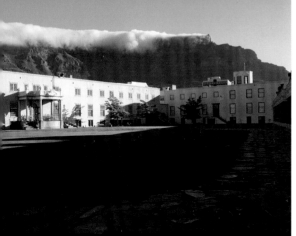

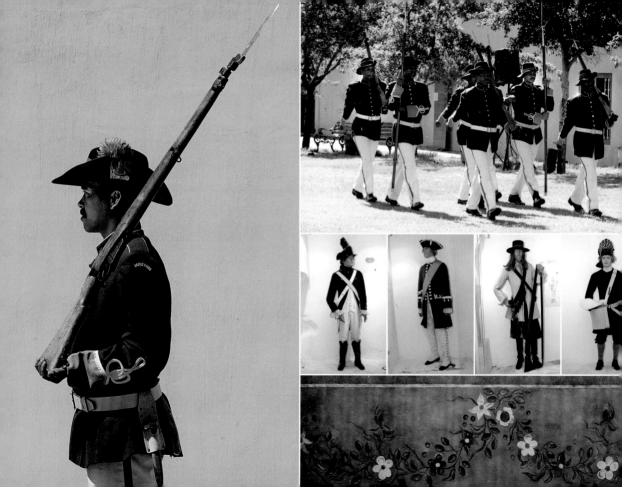

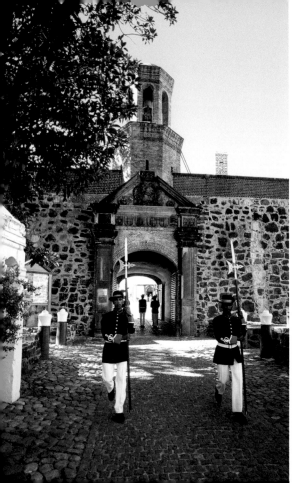

THE CASTLE ENTRANCE

The entrance and bell tower of the Castle is a fine example of seventeenth-century Dutch classicism. The bell, still hanging from its original wooden beams, was cast in 1697 in Amsterdam and served the Dutch East India Company at the Cape for 150 years. It not only struck the hours, but also summoned citizens to hear proclamations. On the graceful pediment of the gateway are the arms of Delft, Amsterdam, Rotterdam, Hoorn, Middelburg and Enckhuijzen – chamber cities of the Dutch East India Company. The Castle houses the headquarters of the South African army in the Western Cape, the Castle Military Museum and the William Fehr collection. This collection reflects the lifestyle, art and culture from the Company's early days at the Cape to the end of the nineteenth century.

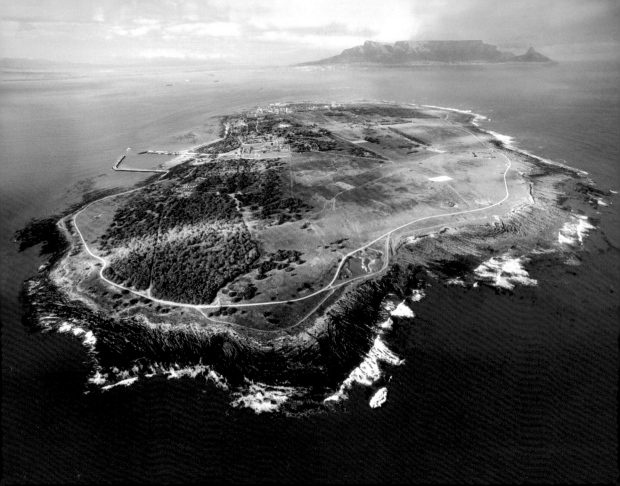

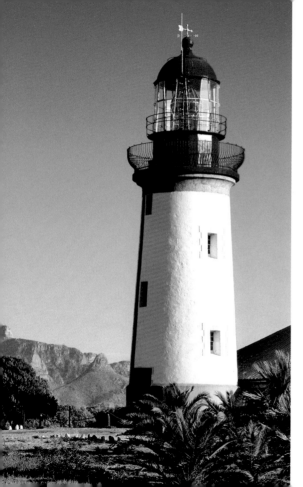

ROBBEN ISLAND

Robben Island was used as a posting station by passing ships from the sixteenth century, and by subsequent governments as a prison: the Dutch kept prisoners from their East Indian colonies there. During the nineteenth century, able-bodied prisoners were transferred to the mainland for manual labour, and the prison population on the island increasingly came to consist of the infirm. It later became a leper colony. During the Second World War the island was part of South Africa's coastal defences. In 1960, it became a high-security prison, housing political prisoners. A world heritage site, it is now a site of pilgrimage and an important tourist attraction.

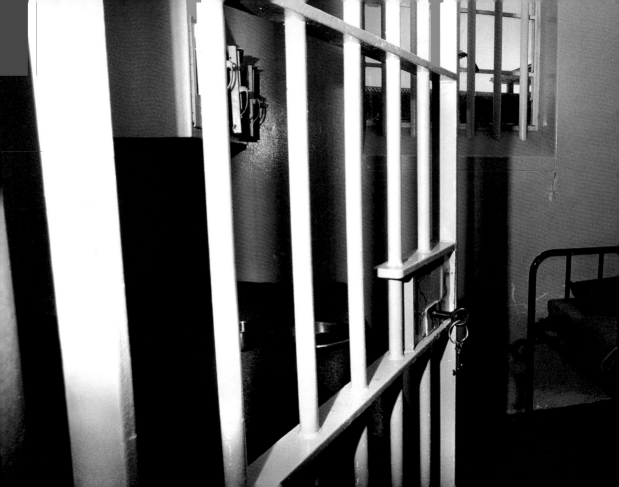

NELSON MANDELA'S CELL

In 1960 Robben Island became a maximum-security prison for political prisoners. In 1964 the Rivonia trialists, including Nelson Mandela, Walter Sisulu, Govan Mbeki and Ahmed Kathrada, were convicted of treason and sent there. The island became known as 'the university', as those who had special skills and knowledge shared them with others, and they kept a system of classes and tutorials going throughout their years there. After the youth uprising of 1976 and the rise of Black Consciousness, a new generation of prisoners engaged the older generation of inmates in fierce debates over both political philosophy and practical tactics.

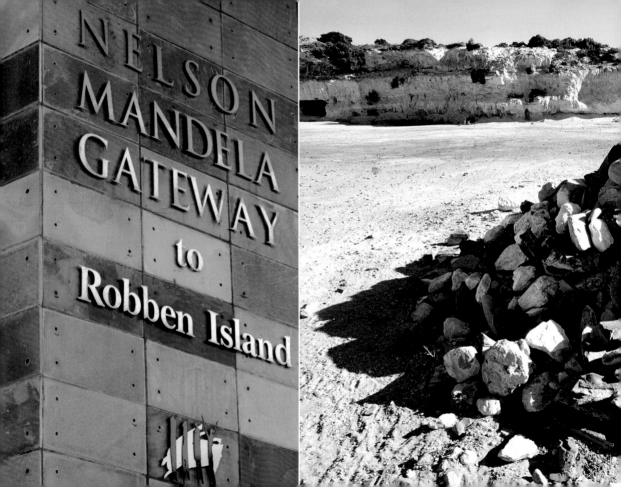

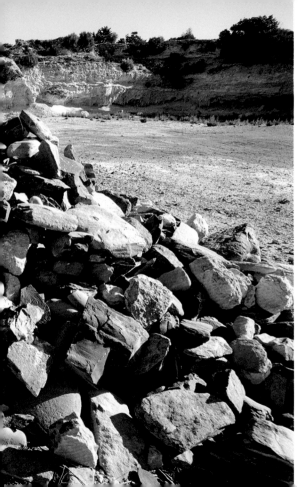

HARD LABOUR

This limestone quarry is where Nelson Mandela and other political prisoners toiled during their incarceration on Robben Island during the apartheid era.

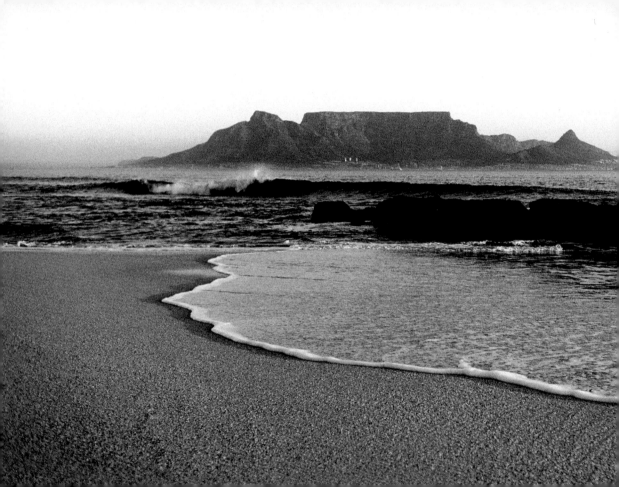

TABLE MOUNTAIN FROM BLOUBERGSTRAND

Rising like a phoenix out of the Atlantic, Table Mountain, a massif of granite, sandstone and shale, stands as a beacon of safe harbour. For early European travellers, the mountain represented a welcome mid-point on the trade route between home and the East. It was a place where supplies could be replenished and preparations made for the final leg of the journey. It has always been invested with a spiritual significance, and today some esoteric philosophies regard Table Mountain as a powerful world energy site, representing earth, one of the four elements.

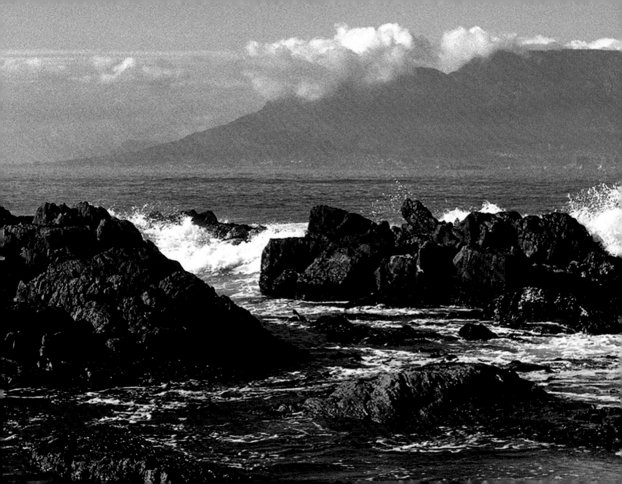

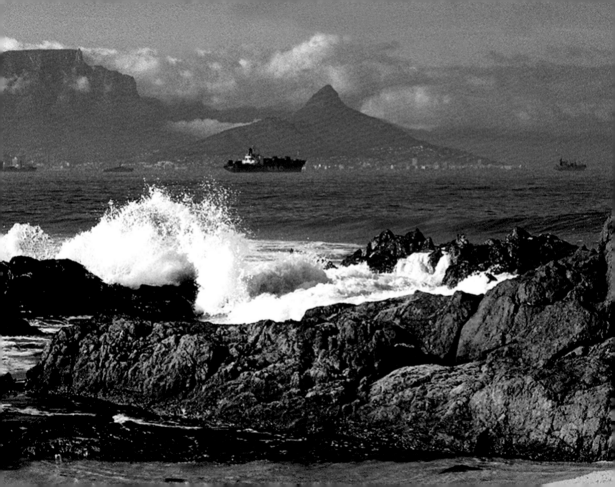

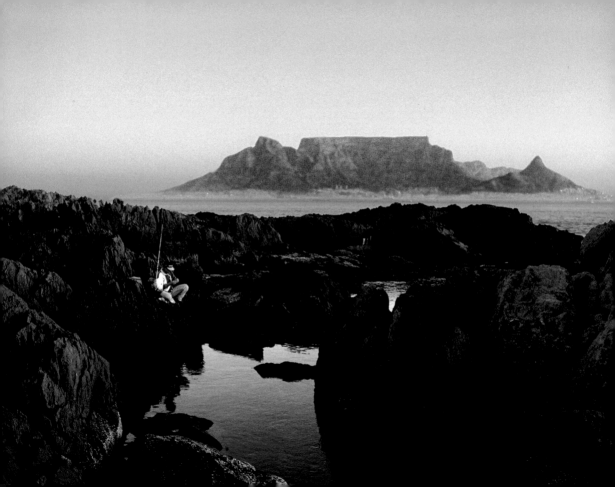

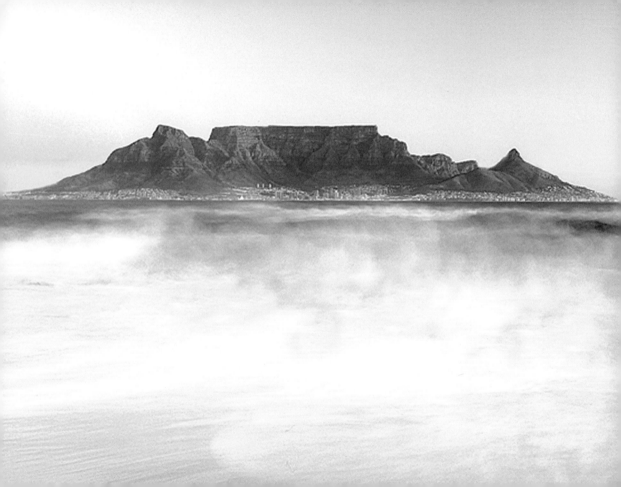

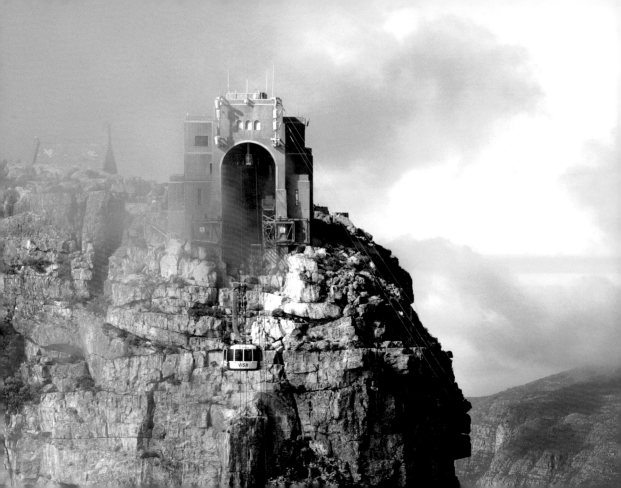

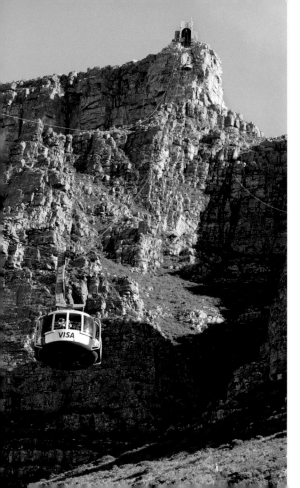

TABLE MOUNTAIN –
THE NEW CABLEWAY

The cableway was renovated in 1997 to accommodate increasing numbers of visitors to the city's most famous landmark. The new system is designed to be safer, faster and more wind resistant than its predecessor, with rounded cabins allowing panoramic views. Each car takes 65 passengers. Elevators at both stations separate arriving and departing passengers, reducing congestion. Safety features include track brakes which can lock the cars onto the track ropes and a winch that can lower passengers to the ground. The engine house is now in a glass building at the lower station where visitors can see the machinery in operation.

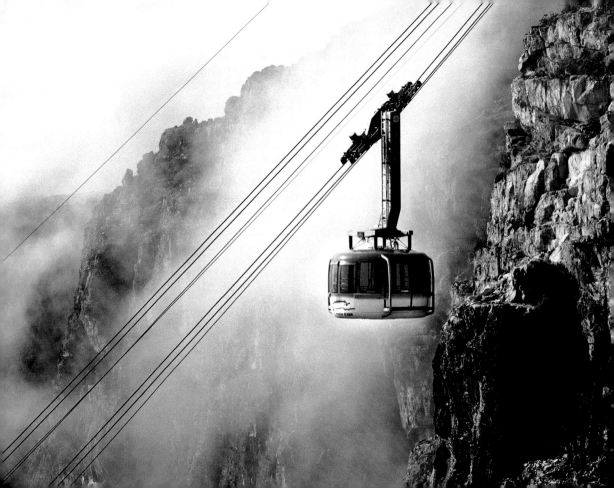

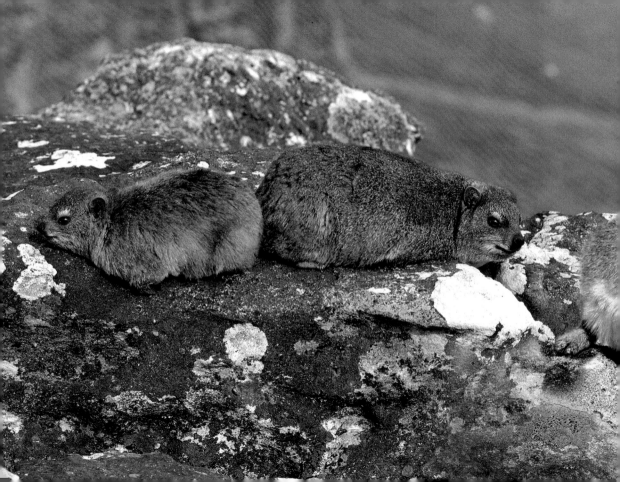

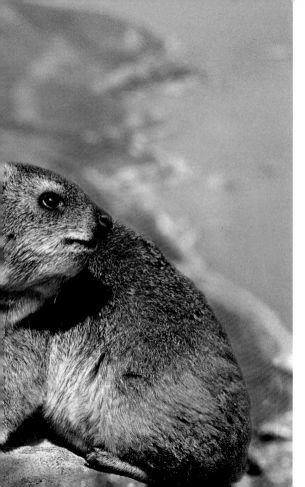

ROCK HYRAX

A common sight on Table Mountain are the dassies (hyrax) – small, gregarious animals, rodent in appearance but more closely related to the elephant. These animals, found in colonies of up to 50, are fast feeders, grazing for less than an hour per day. Their poor temperature regulation mechanism forces them to spend most of the day soaking up the warmth of the sun, but they keep to their warrens in extreme temperatures. When alarmed, they make a quick dash for shelter, moving with great agility across sandstone cliffs where traces of fossilised marine life 400 million years old bear witness to the antiquity of Table Mountain.

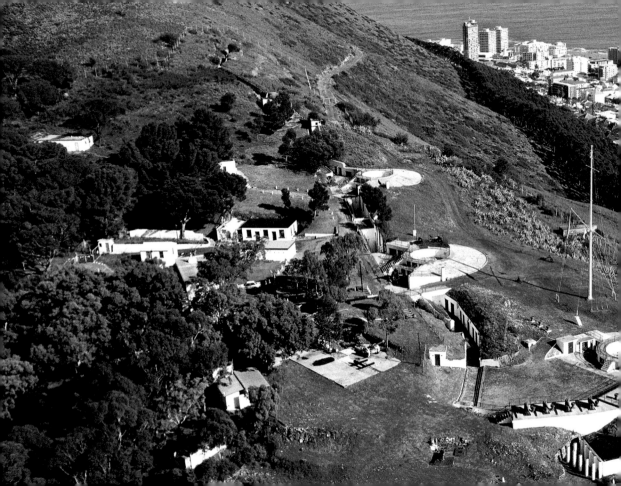

THE NOON GUN

From Mondays to Saturdays at noon the city bowl reverberates to the sound of an 18-pounder gun situated at Lion Battery on the slopes of Signal Hill. The tradition began in 1807, allowing passing ships to measure the accuracy of their chronometers. Originally located at the Imhoff Battery at the Castle, the noon gun was relocated to Lion Battery in 1902. It is one of Cape Town's five surviving 18-pounders cast in England during the reign of King George III (1760–1820). During the First and Second World Wars a two-minute silence at the sound of the noon gun was instituted to remember the men at the front.

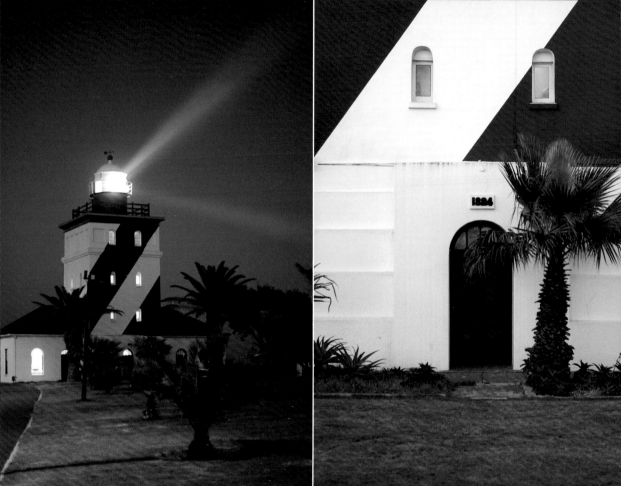

GREEN POINT LIGHTHOUSE

The red-and-white candy stripes of the Green Point lighthouse are as familiar as the haunting sound of its foghorn on a mist-shrouded night. The oldest working lighthouse on the South African coast, it was built in 1824 by Herman Schutte, a German builder who came to the Cape in 1789. The original lighthouse contained two fixed lanterns which burnt 9 litres of sperm oil every night, producing a light visible up to 21 km out to sea. In 1865 revolving glass lenses were installed to make a single flashing light. The lighthouse was electrified in 1929.

DASSEN ISLAND *(overleaf)*

This beautiful uninhabited island, with its magnificent Victorian lighthouse, is in the line of sight of Table Mountain. A wildlife sanctuary, it is festooned with wild Arum lillies in spring. African penguins cavort in the surf. and share the island with tortoises, rabbits and abundant bird life. Once guano and penguin eggs were harvested here. Restricted, environmentally sensitive tourist accommodation is planned in the near future.

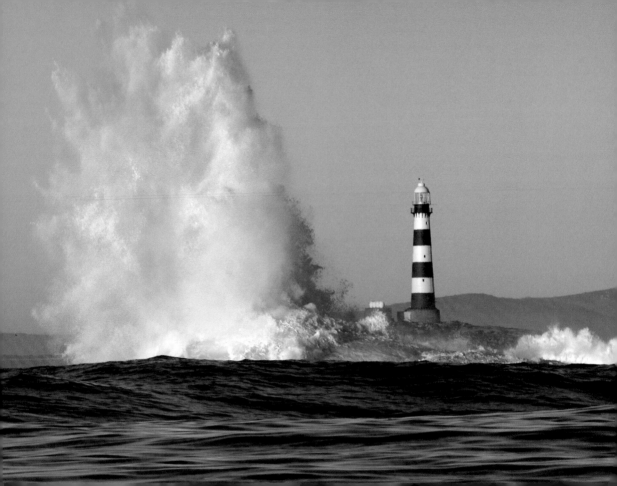

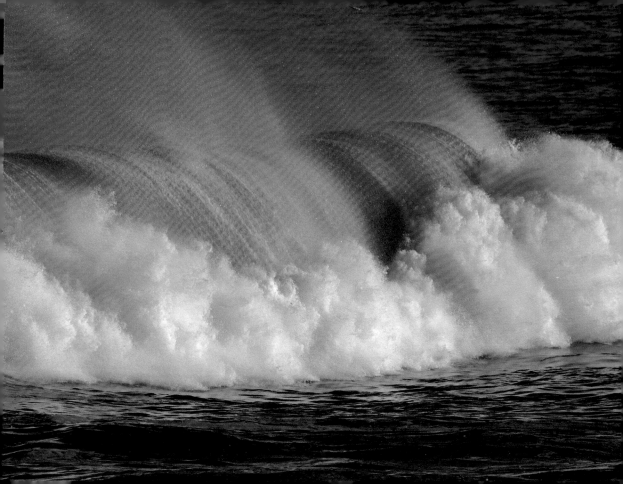

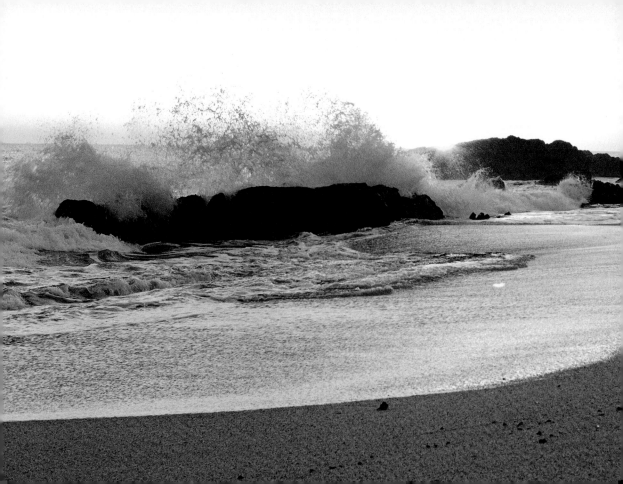

THE 'SECRET SEASON'

In the tourism industry it's known as the 'secret season'. Cape Town's winter months have long been thought to be wet, cold and, well, unpleasant. But for those in the know, it's one of the best times of the year to visit these shores, with mostly sunny weather interspersed with a few days of drizzle. By all accounts, the word's been spreading: according to tourism authorities, more and more visitors flock to the city during the winter season. And what better way to recharge your batteries on a sunny winter's day than to take a long walk on an unspoilt beach.

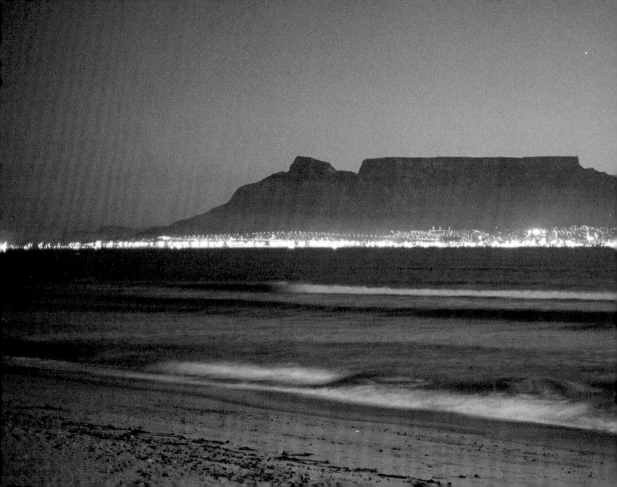

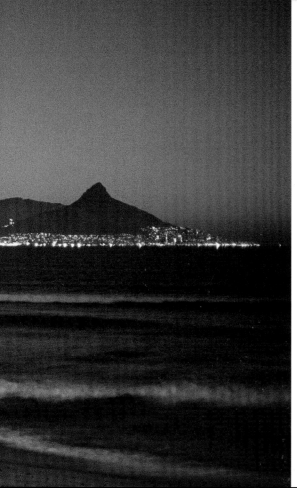

CAPE TOWN AT NIGHT

For Capetonians a daily dose of sun, sea and fresh air is part of the rhythm of life. Come the end of the working day, they're out on the beaches, bursting the bubbly, tucking into deli fare bought on the way to their favourite strip of sun-bleached sand, and soaking up the last heat of the day. As night falls, burning candles flicker along the shoreline like miniature lighthouses. But by far the city's best-kept secret is this long stretch of beach – and the stunning view of Cape Town and Table Mountain – at Bloubergstrand where at dusk the only sounds that can be heard are those of gently lapping waves and seagulls calling.

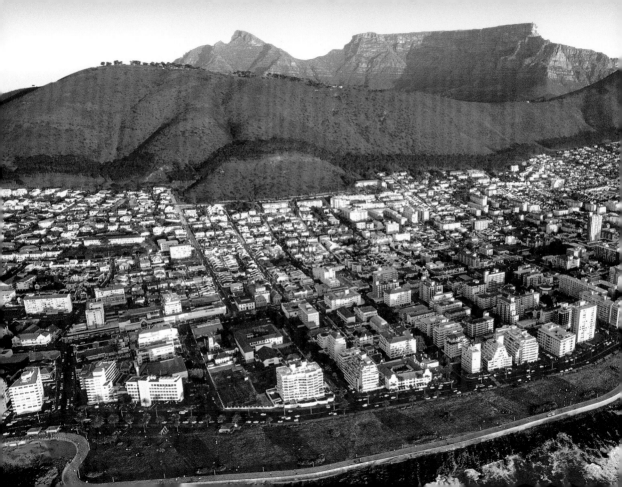

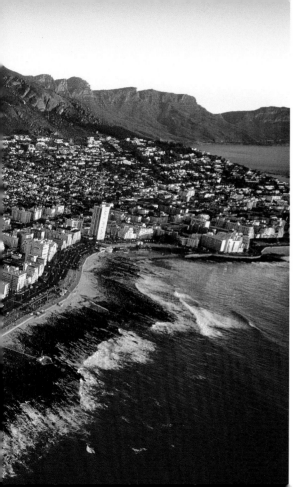

SEA POINT

Lion's Head, with Table Mountain rising over the ridge of Signal Hill, forms an exquisite backdrop to the high-density, cosmopolitan suburb of Sea Point. Its famous promenade curves along the coastline where waves tumble over angular sedimentary rock, their contorted shapes jutting skyward. At the southernmost end of the promenade is the Sea Point Contact – a remarkable geological zone where, 650 million years ago, molten granite magma penetrated the near-black rocks of Malmesbury shale. The occurrence, usually found 10 km below the surface, was first recorded by Clark Abel in 1818, and the site was visited by Charles Darwin in 1836.

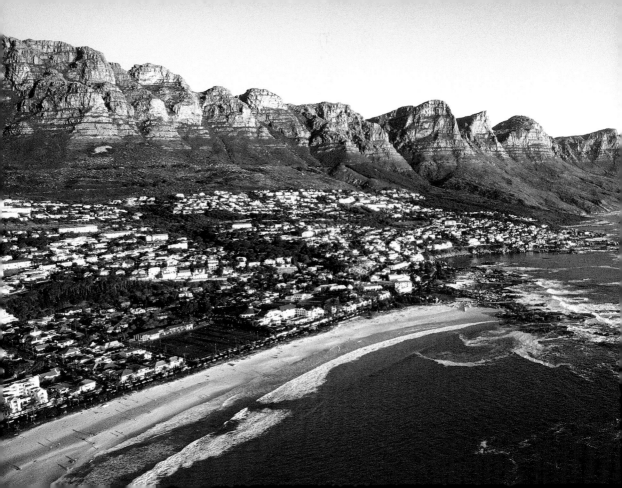

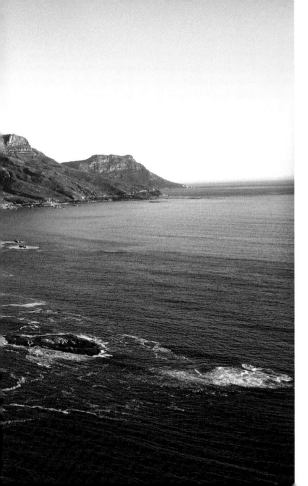

CAMPS BAY

Named after a German sailor, Friedrich von Kamptz, who arrived at the Cape in 1778 and married the owner of a farm on the site of the modern settlement, Camps Bay was originally a Khoikhoi site. With its wonderful views west over the Atlantic Ocean, Camps Bay is popular with beach lovers, while neighbouring Glen beach is a haven for surfers. To the east the legendary buttresses of Table Mountain, called the Twelve Apostles, run along the Atlantic seaboard towards Hout Bay. Camps Bay boasts several fine restaurants and a thriving theatre, and its beach offers one of the best settings for a sunset picnic.

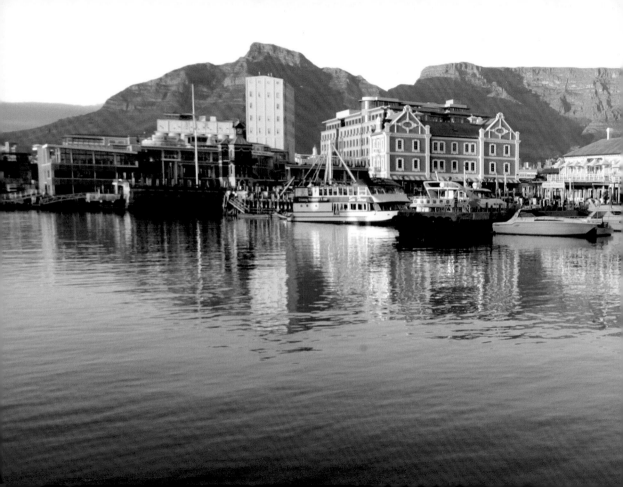

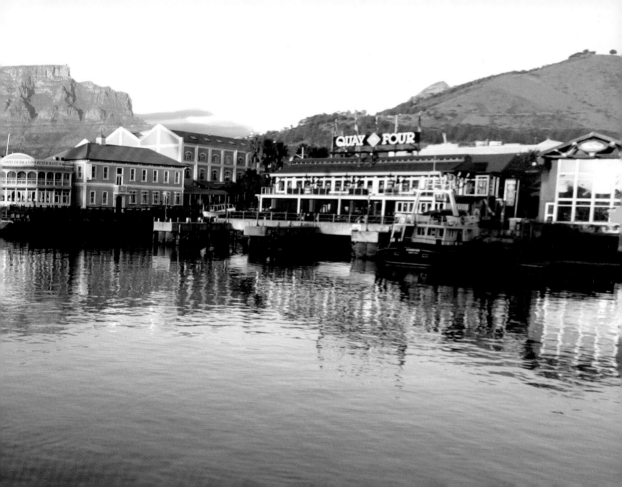

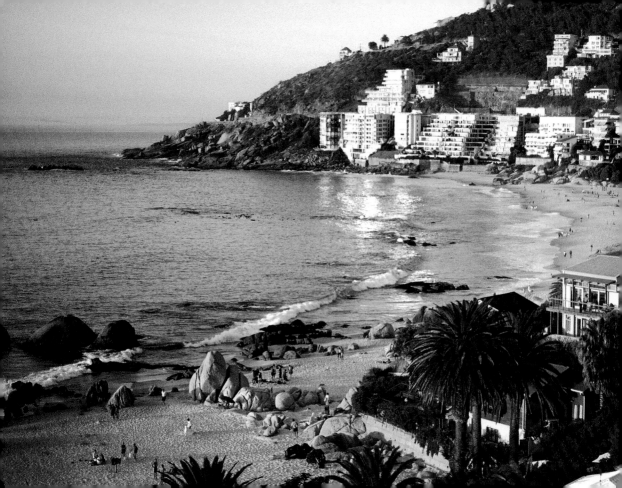

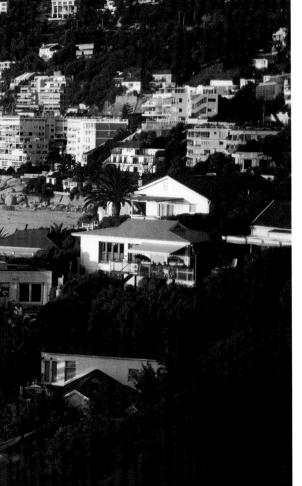

CLIFTON AT SUNSET

Every summer, hundreds of sun lovers flock to Clifton, Cape Town's most glamorous quartet of beaches. The beach is divided by huge granite boulders to form separate coves. According to local custom, the largest of the beaches, Fourth beach, is favoured by families, while First, Second and Third are frequented by teenagers, students and twenty- to thirty-somethings. Clifton is a haven on days when the south-easter blows. Along the rim of Clifton lies some of the city's most coveted real estate. Originally built during the First World War as temporary housing, the seaside bungalows have since been converted into stylish homes.

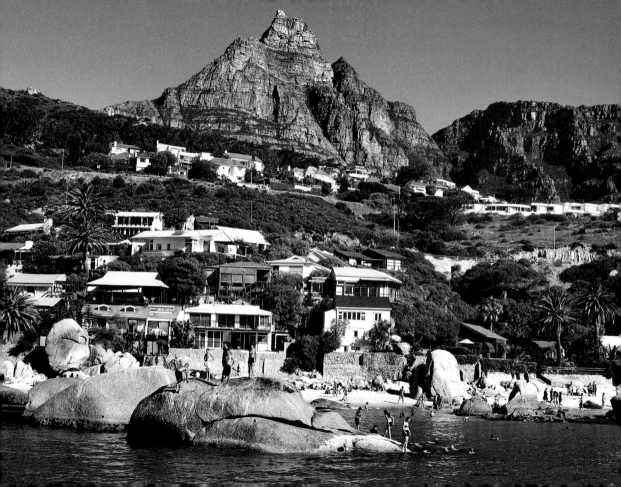

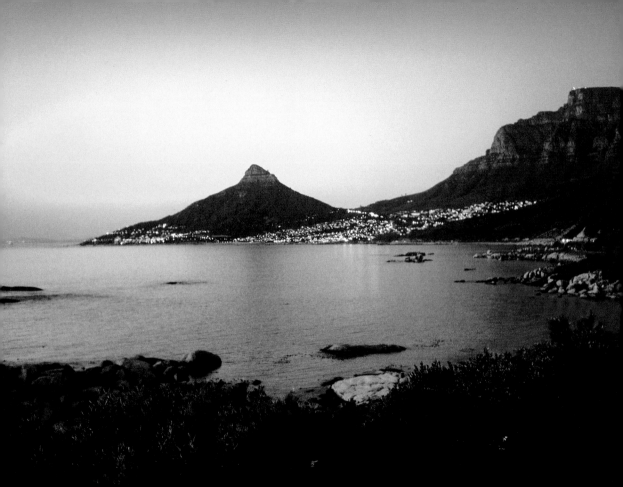

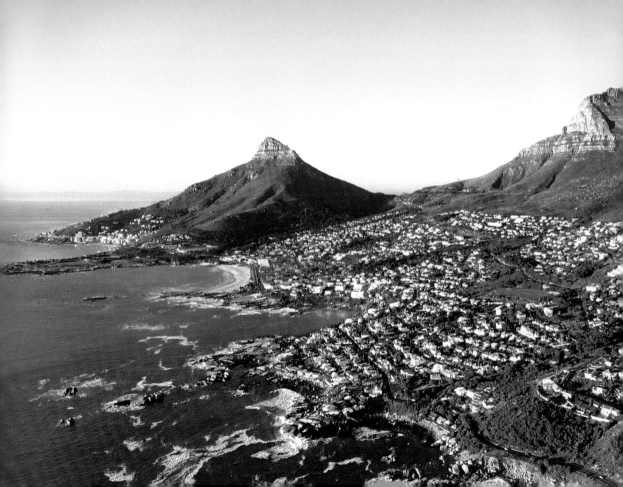

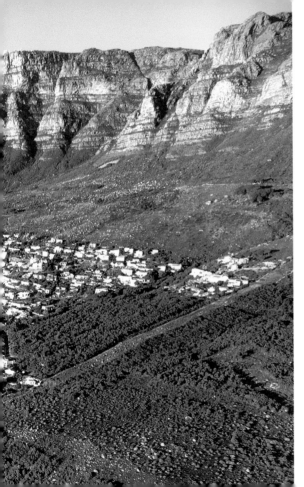

OUDEKRAAL

Lion's Head casts a dignified eye over the Atlantic suburbs of Bantry Bay, Clifton, Camps Bay and Bakoven. The ocean drive snakes along the rocky coast – scattered with giant granite boulders and idyllic picnic and fishing spots – connecting Cape Town with the enclave of Hout Bay. Situated beyond the last suburb, Bakoven, on the land known as Oudekraal, the Kramat (holy shrine) of Sheikh Noorul Mubeen, apparently banished to the Cape and imprisoned on Robben Island in the eighteenth century, can be found. One of three prominent shrines along the mountainside, it can be reached by ascending the 99 steps from Victoria Road.

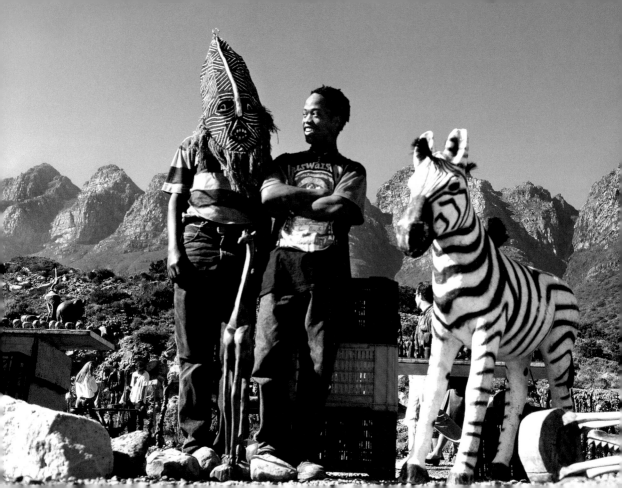

CURIO SELLERS AT OUDEKRAAL

Cape Town markets abound with the precious wares and exotic curios sold by traders from across Africa, from Ghana to Nigeria, Mozambique to Malawi. Often driven by poverty, war and the lack of opportunity back home, they flock to the continent's southernmost city where they trade at local markets, on street pavements and along the rocky shoreline of the Cape Peninsula. Like so many settlers before them, they have come in search of prosperity and a good life; for at Africa's Land's End is a port of plenty, a cape of good hope.

AFRICAN MASKS *(overleaf)*

These examples of fine art collectables from across the continent are each a unique cultural statement, powerfully evocative of Africa.

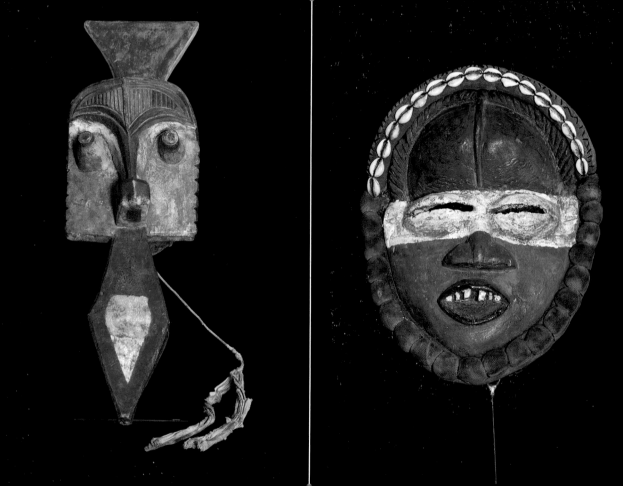

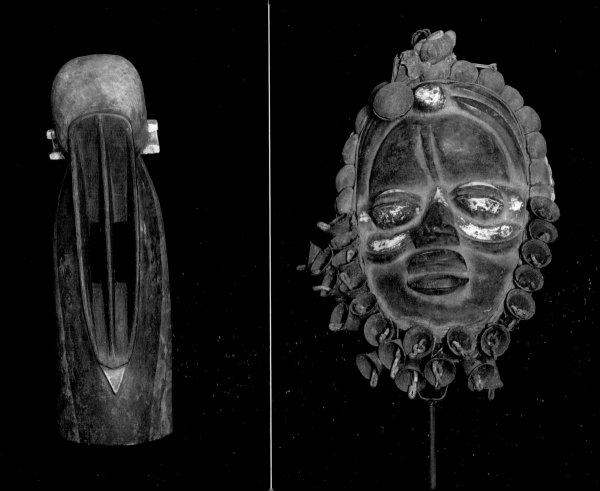

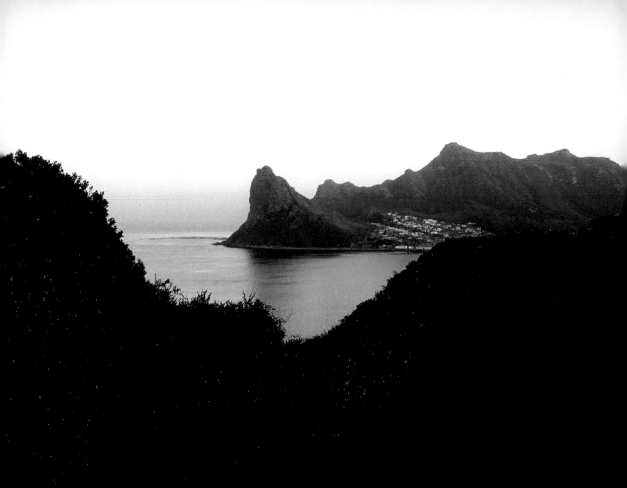

HOUT BAY

Hout Bay (literally 'Wood Bay') takes its name from the once densely forested slopes of the surrounding mountains. On his first expedition to Hout Bay in 1653, Jan van Riebeeck described the forests as the 'finest in the world'. In 1662 the road to Kirstenbosch was extended over Constantia Nek to Hout Bay, and the area's timber began to be felled for fuel and ship repairs, destroying large tracts of forests. Patches of indigenous forest can still be found in the higher gorges of Table Mountain. Today the peninsula's largest area of re-established mountain forest can be found in the Orange Kloof Reserve above Hout Bay.

Hout Bay was a strategic settlement for successive governments at the Cape. Not only was its timber a valuable commodity and its bay a temporary port for vessels unable to brave the storms off Cape Point, it also had to be fortified to prevent enemy ships from refuelling or docking there. During the Napoleonic wars, three forts were built on the west side of the bay by the Dutch, and two years later, in 1796, the British built the East Battery blockhouse, deploying a guard of 130 soldiers to deter French ships from calling at Hout Bay. The remnants of these well-preserved fortifications have been declared national heritage sites.

113

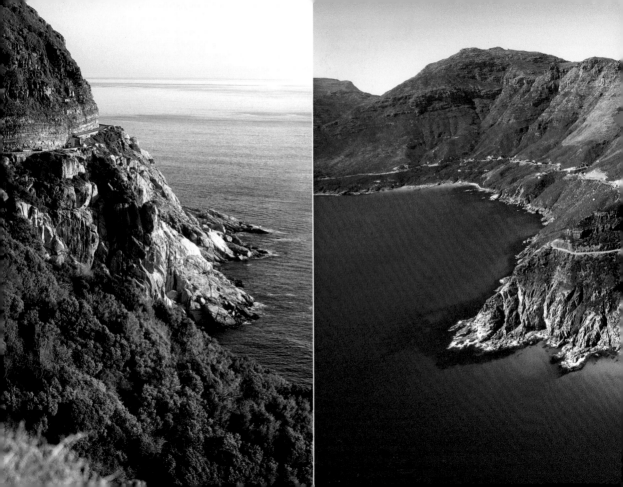

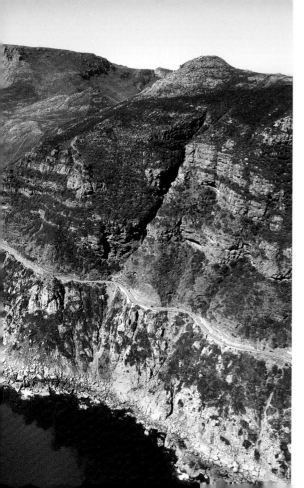

'A ROAD OF PLEASURE'

Prince Arthur of Connaught, then governor-general, opened Chapman's Peak Drive on 6 May 1922. It was classified, at the insistence of Sir Frederick de Waal, as a motor-only road – in other words, only vehicles with pneumatic rubber tyres were allowed to use it. This was ostensibly to protect the gravel surface, but also had the effect of restricting use of the road to people wealthy enough to own motor cars. The Cape Divisional Council opposed this development, but was overruled by De Waal, who justified this classification on the grounds that 'it was not a road of necessity at all, but entirely and solely a road of pleasure'. The cuttings along Chapman's Peak Drive expose the geological structure of the Table Mountain chain – below the road is Cape granite, while above are layers of sandstone, silt-stone and shale with colours ranging from grey to red and purple.

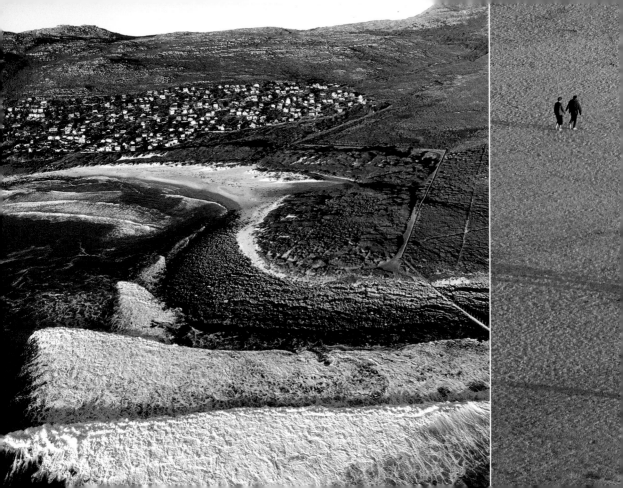

NOORDHOEK BEACH

The area was settled in the eighteenth century by a small number of Dutch farmers, who supplemented their income by catching and salting fish for the Cape Town market. A salt pan on the farm Imhoff's Gift – one of the largest farms in the valley at the time – was mined for the salt that was used in the fish-salting process. In 1923 Sir Drummond Chaplin, formerly administrator of Rhodesia, bought 600 acres of farmland in Noordhoek, where he initially grew proteas before planting an indigenous forest of ironwood, rooi els, wit els, yellowwood and assegaai trees. Nowadays Noordhoek is known chiefly for its magnificent stretch of sandy beach.

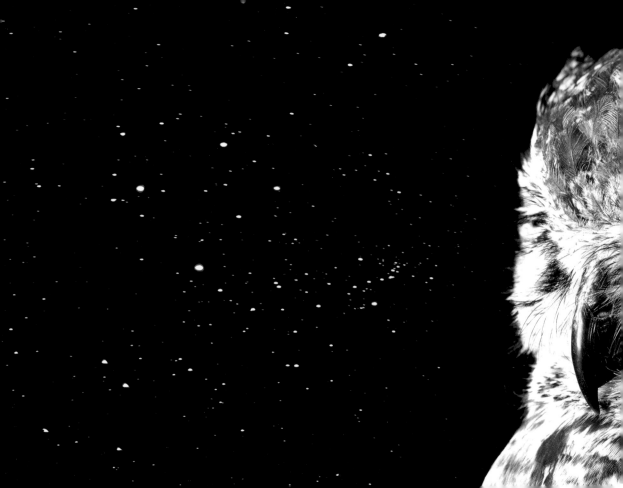

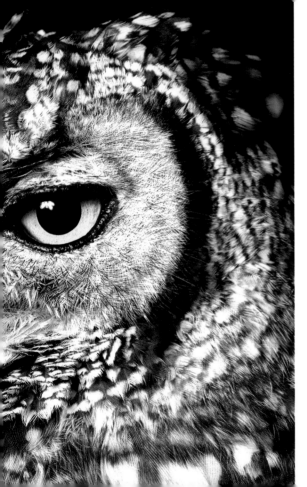

THE CAPE EAGLE OWL

A nocturnal, and usually solitary, bird of prey, the Cape eagle owl *(Bubo capensis)* is a large owl, with females weighing up to 1.8 kg. The Cape eagle owl, with its acute hearing and excellent night vision, lives a secluded life, mainly in mountains, hills and rocky outcrops. In the southwestern Cape it also inhabits vegetation types such as fynbos, preferring to frequent rocky ledges in these habitats. Its loud, deep hoot, ringing out into the dark of the night, is distinctive. The owl feeds on small mammals, birds, lizards and insects, and its soft plumage enables it to swoop noiselessly on its prey.

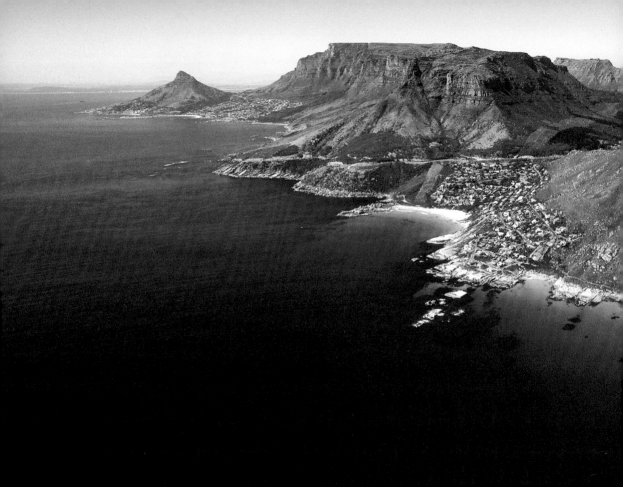

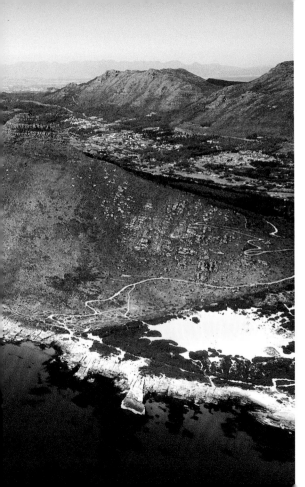

THE WESTERN SEABOARD

The awesome wonder of the Cape Peninsula is rivalled by the treasures of its marine world. Divers can marvel at the vivid colours of marine life growing on the walls of the underwater caves at Camps Bay, while the Coral Gardens diving site near Oudekraal is a kaleidoscope of brilliantly coloured coral, sea urchins and anemones. The turquoise waters are also home to several shipwrecks which, over time, have been transformed into underwater gardens, providing homes for invertebrates, small fish and kelp forests. The sea between Melkbospunt on the west coast and Hout Bay is a crayfish reserve. The removal of this crustacean is forbidden.

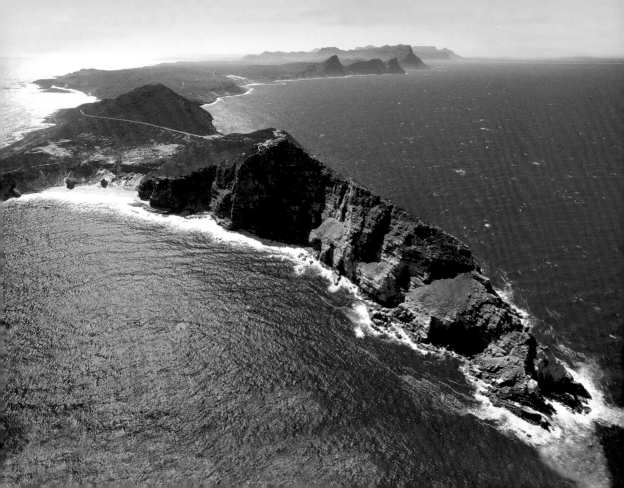

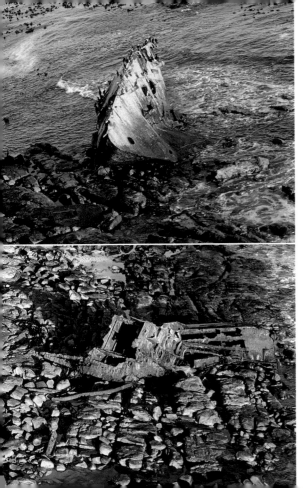

CAPE POINT

Cape Point is a rocky promontory at the end of the mountain chain of the Cape Peninsula; it points south and east, towards Cape Agulhas, the southernmost tip of Africa, where the Indian and Atlantic Oceans meet. There are two lighthouses: the older one, built in 1859, was wrongly positioned – the light was enveloped by fog much of the time. After the Portuguese ship, the Lusitania, was wrecked in 1911 on Bellows Rock off Cape Point, the new lighthouse was built. It is the most powerful lighthouse on the South African coast, with a range of 63 km.

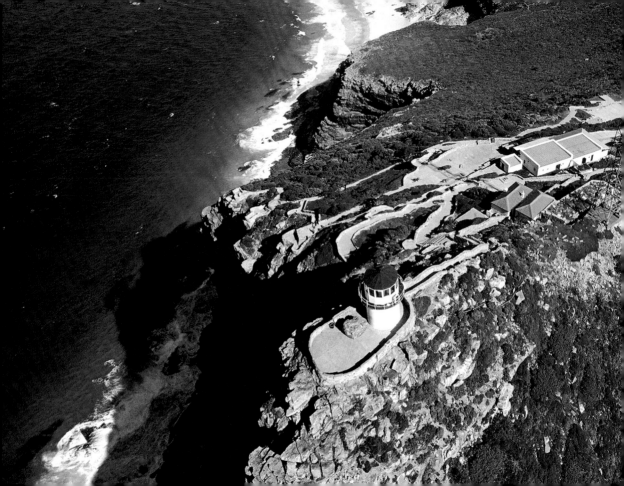

CAPE POINT PEAK

Situated at the summit of Cape Point Peak, 266 m above sea level, the old lighthouse can be reached by foot or, perhaps less strenuously, by funicular railway. Once at the top, it is a short climb to reach the red-topped lighthouse from where the vast panorama of deep blue sea and surrounding mountains can be viewed. The more adventurous can choose from an array of recreational options in this area, such as year-round bird-watching, hikes through rocky outcrops and along coastal plains, a motor trail through the fynbos, rock angling from spectacular heights, or a visit to a shipwreck.

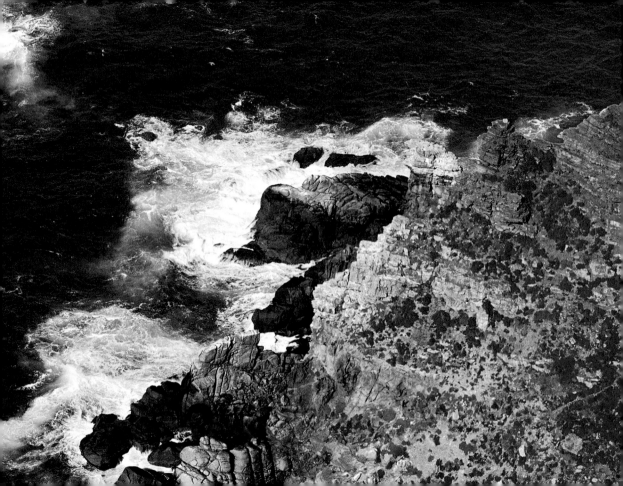

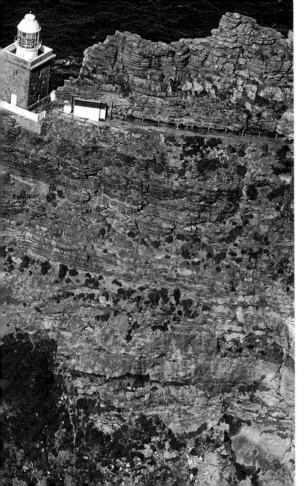

CAPE POINT – NEW LIGHTHOUSE

The second lighthouse was built on the lower cliffs overlooking Diaz Rock at the edge of the sea. Stone for the building was quarried nearby and sand was carried 90 m from a cave below. The building was completed in 1919, six years after construction began. Many ships have come to grief along this rugged coastline, including the legendary *Flying Dutchman*, which, since its shipwreck in 1680, has been said to haunt these waters. There have been several documented sightings of the ghost ship, including one logged in 1881 by King George V of Britain. The *Flying Dutchman* is the subject of an opera by Richard Wagner.

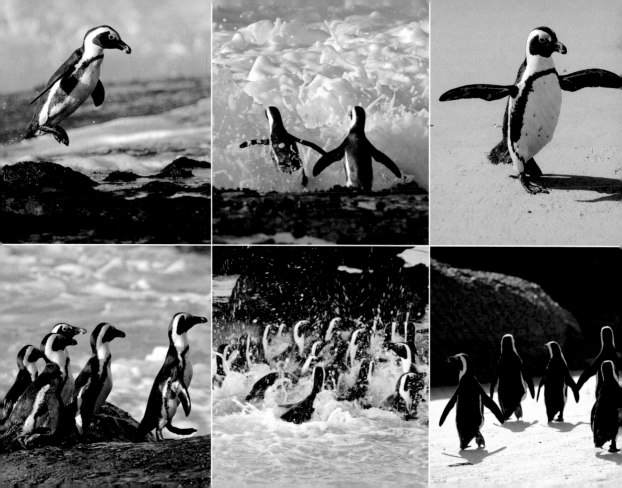

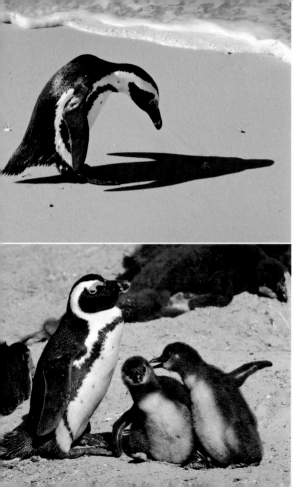

AFRICAN PENGUINS

Africa's only indigenous penguin, the African or jackass penguin *(Spheniscus demersus)* is found along the southwestern coastal regions of southern Africa and on offshore islands. Robben Island was originally called Penguin Island by English sailors, but was renamed (from the Dutch word for seal) by the Dutch, who valued seals for their oil. Both species were plentiful on the island when European ships began to call there. However, by the nineteenth century neither penguins nor seals were to be found on Robben Island, but in the early 1980s the penguins began to return, and there is now a sizeable colony there. On the mainland, a penguin colony can be found at Boulders beach.

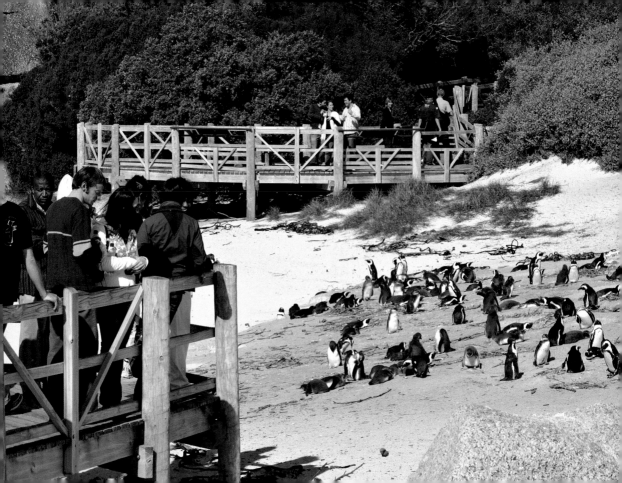

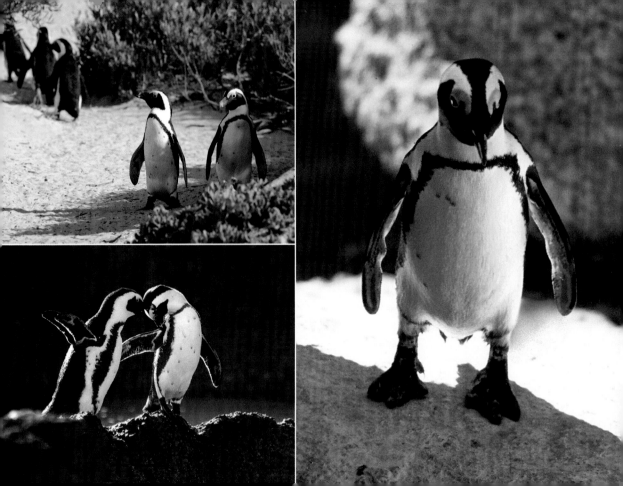

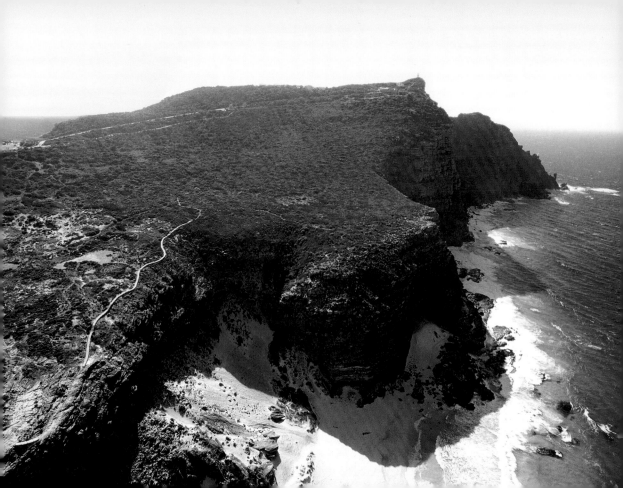

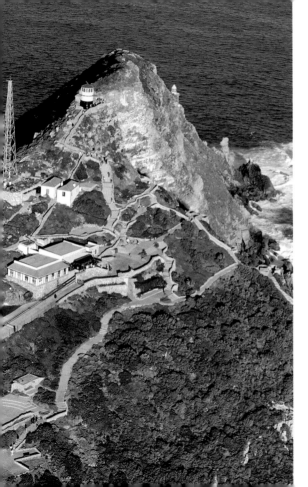

DIAZ BEACH

A 200-step staircase winds through the low-lying coastal fynbos down to the white sandy bay of Diaz beach – a secluded hideaway protected from the wind by the steep cliffs of the Cape of Good Hope. This section of the coastline is ideal for bird-watching, especially in winter when birds that breed in the Antarctic visit the waters off the Cape coast. The cliffs are also the nesting-place of the Cape, bank and white-breasted cormorants. Perched on Cape Point Peak and Cape Point in the distance, the two lighthouses can be seen from Diaz beach.

CHACMA BABOONS

The chacma baboon *(Papio hamadryas ursinus)* can be found in arid and savanna zones throughout southern Africa. They were first described from Cape Point in the present-day Table Mountain National Park, and the name – derived from the Khoikhoi 'chacma', 'choachamma' or 'choa kamma' – was introduced by the French zoologist F. Cuvier. The park is home to the world's most southwesterly-dwelling primates (other than humans): four troops of chacma baboons, each with an average of 50 baboons, are found in the park's Cape Point section. They spend most of their time in the rocky hills of the central plateau, but their territory spans the entire reserve. Uniquely, one troop also ranges along the coast, where its members forage for shellfish and other sea-life. The chacma baboons are characteristically omnivorous, but feed mainly on approximately 114 types of plants in the reserve. Adult males are double the size of adult females and can be identified by hairy manes on the backs of their shoulders and necks, and their fierce-looking canine teeth. Although their basic colouring is brown, baboons vary in colour depending on their sex and age. Adult males are dark brown with a tinge of yellow, especially on the forehead.

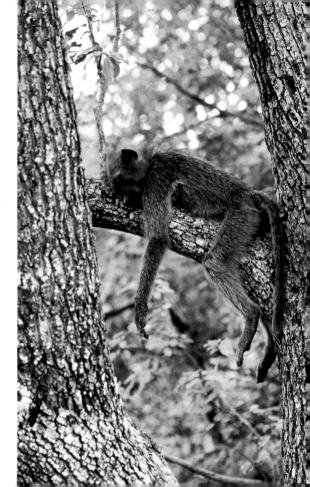

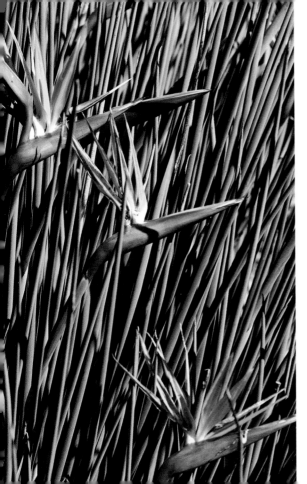

THE REED STRELITZIA

The strelitzia *(Strelitzia juncea)* was named after Princess Charlotte of Mecklenburg-Strelitz, wife of George III of Britain, whose personal plant collector, Francis Masson, discovered the species in the late eighteenth century. He took it back to Kew Gardens, where to everyone's astonishment it flowered. The striking flowers are a rich orange with blue and white petals. Commonly called the crane flower or bird of paradise, the reed strelitzia is indigenous to the coastal bush of the Eastern Cape and in its natural habitat it can reach a height of up to 2 m. There are other species of strelitzia indigenous to different regions of South Africa, but they lack the bright colours of the well-known reed strelitzia. Almost two decades ago a rare golden-yellow mutant fortuitously appeared in the Kirstenbosch National Botanical Garden, after which it was propagated and finally released in 1996. Known as Mandela's gold, it honours the former South African president, Nelson Mandela, whose ancestral home is in the valleys of the Eastern Cape.

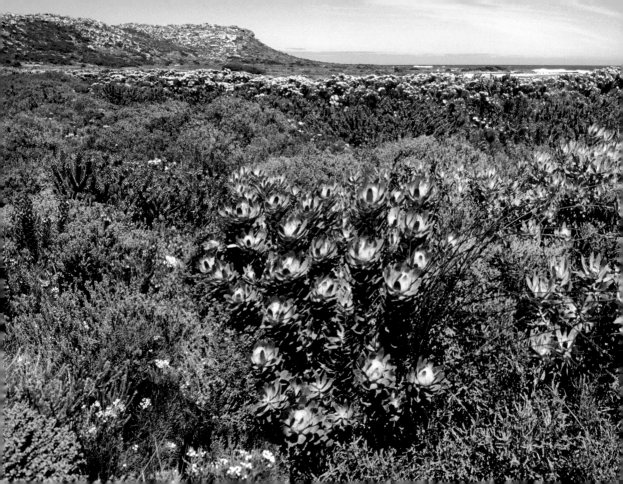

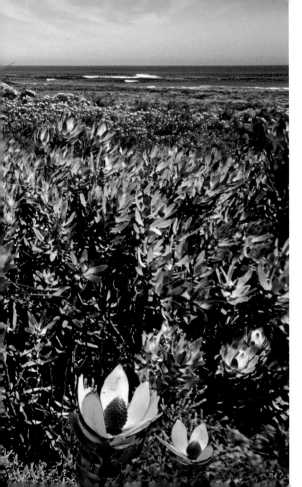

COASTAL FYNBOS

A waist-high thicket of fynbos sweeps across the coastal plains, forming a dazzling patchwork of colours. Throughout its distribution in the Cape, fynbos grows no further than 200 km from the sea. Of the six floral kingdoms in the world, the Cape fynbos biome covers the smallest range. Yet, despite its size, it has the richest diversity of species: while approximately 8,500 plant species occur in the western and southern Cape, there are just 1,440 in the entire British Isles. The name fynbos (literally 'fine bush') was used to describe the world of beautiful and exotic flowers found at the Cape of Good Hope by early Dutch explorers.

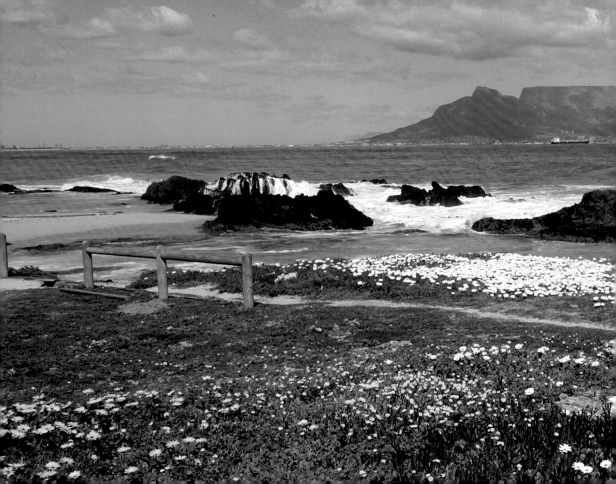

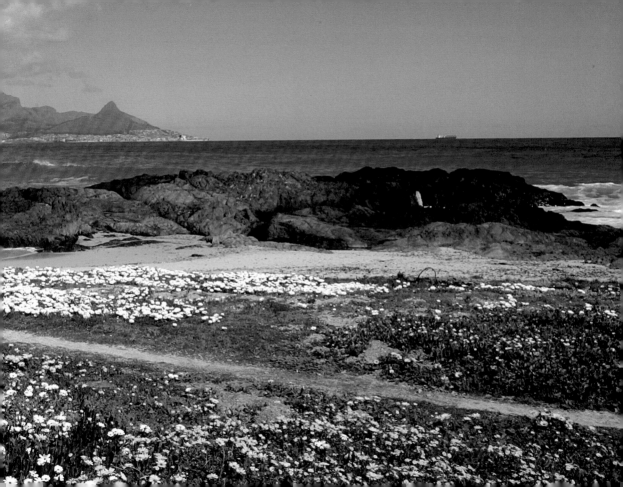

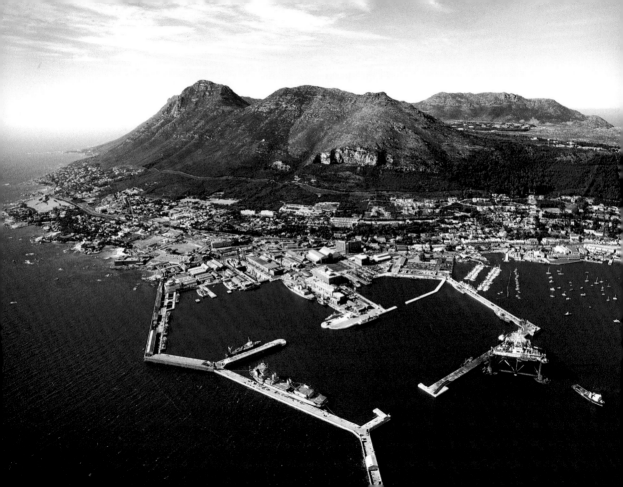

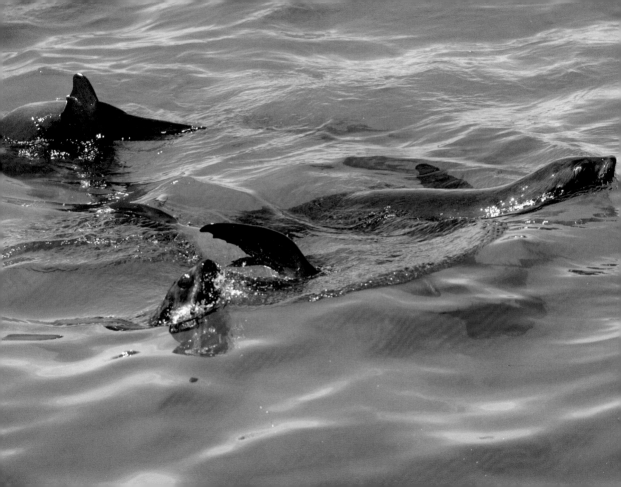

SIMON'S TOWN

Named after the Dutch governor Simon van der Stel, Simon's Town provided the Dutch navy (and merchant and whaling vessels) with a winter haven from Table Bay storms. Occupied by the British in 1795, it became the headquarters of the British South Atlantic Naval Squadron in 1814. Until the railway opened in 1890 the population was mainly seasonal. In the mid-eighteenth century artisans working on the harbour founded a Muslim community. A group from Sierra Leone, ex-sailors from British warships, also settled in Simon's Town. In 1957 jurisdiction of the naval facilities passed to South Africa; it remains the country's chief naval base.

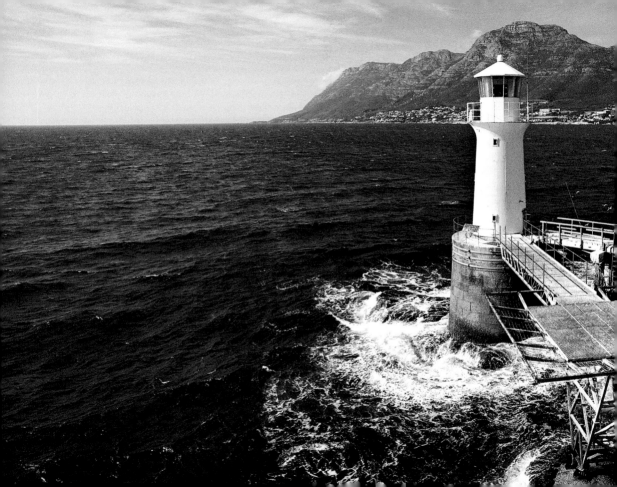

ROMAN ROCK LIGHTHOUSE

Roman Rock lighthouse is situated on an island rock at the entrance to the Simon's Town naval harbour. The prefabricated cast-iron lighthouse, designed by Alexander Gordon, was despatched from England in 1857. It took four years to install and its light – one flash every six seconds – was exhibited for the first time on 16 September 1861. Today the lighthouse is fully automated – with the help of an electrical cable that runs along the seabed from the harbour to the rocky outcrop. More recently a helipad was built to transport heavy equipment used to maintain the lighthouse. The structure reaches a height of 17 m above sea level and its light is visible within a radius of 13 sea miles.

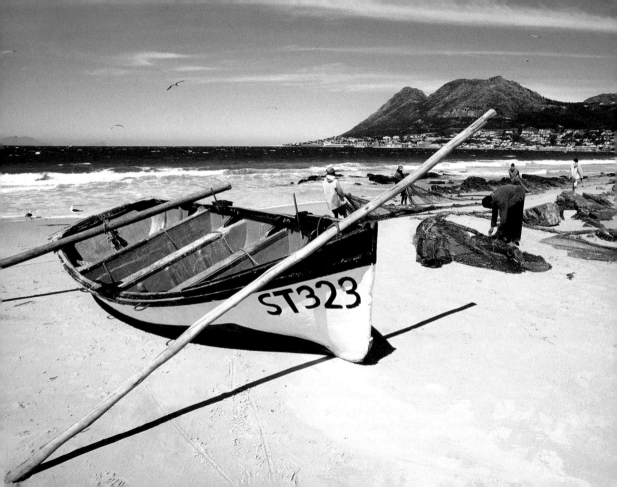

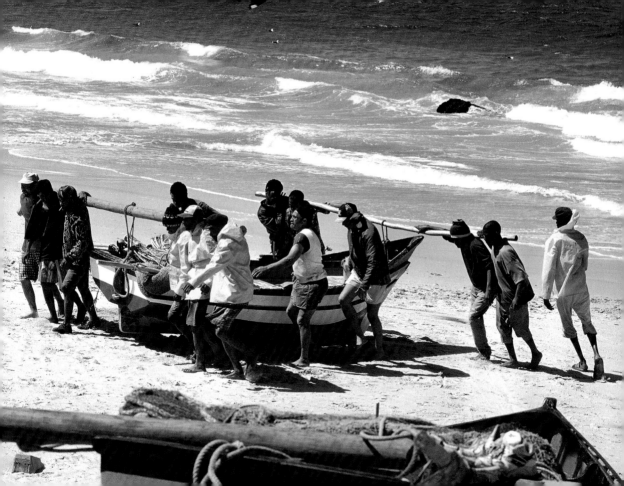

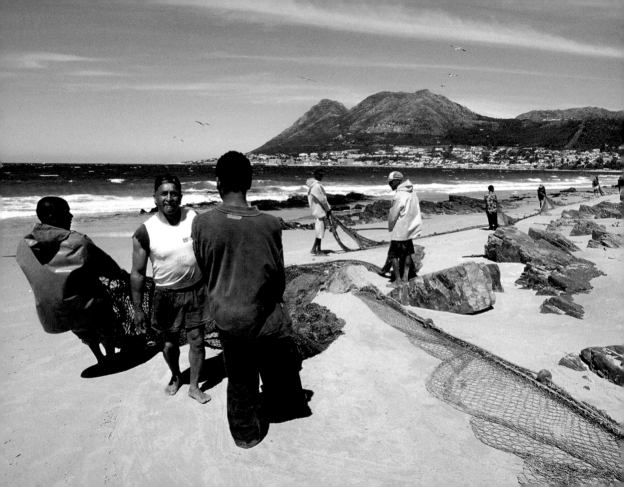

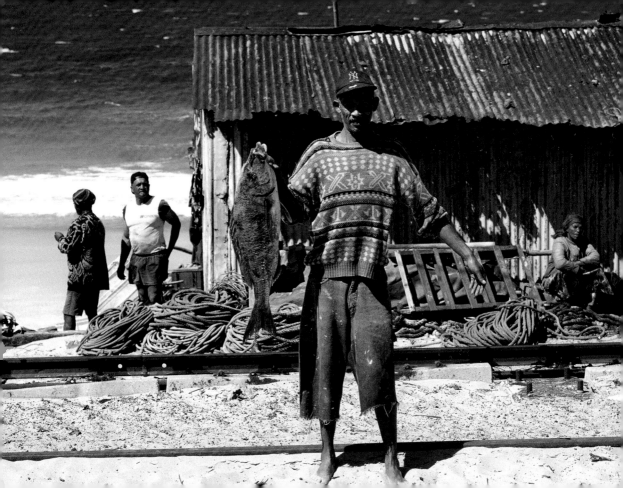

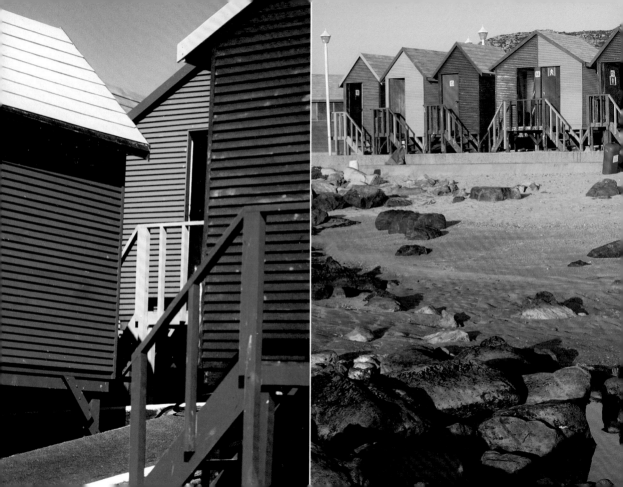

BATHING BOXES AT ST JAMES

Harking back to more modest days, Victorian-style bathing boxes brighten up the wind-sheltered beach at St James. The council-owned bathing boxes can be hired on a daily or long-term basis. St James, on the False Bay coast, is named after the Catholic church built there in 1858 for Kalk Bay's Filipino fishermen who, until then, had to row across the bay to Simon's Town for Sunday prayers.

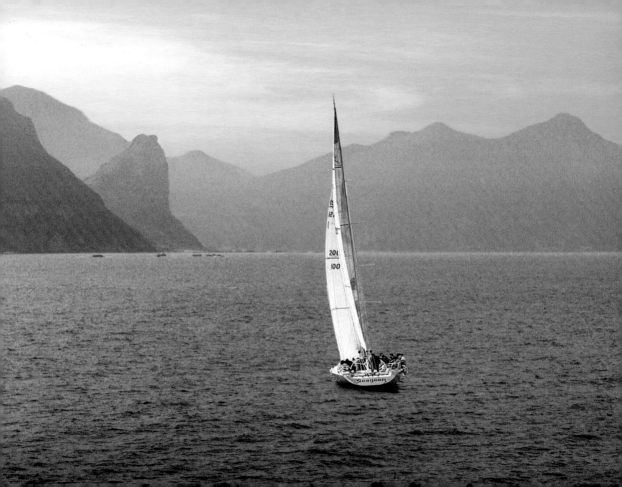

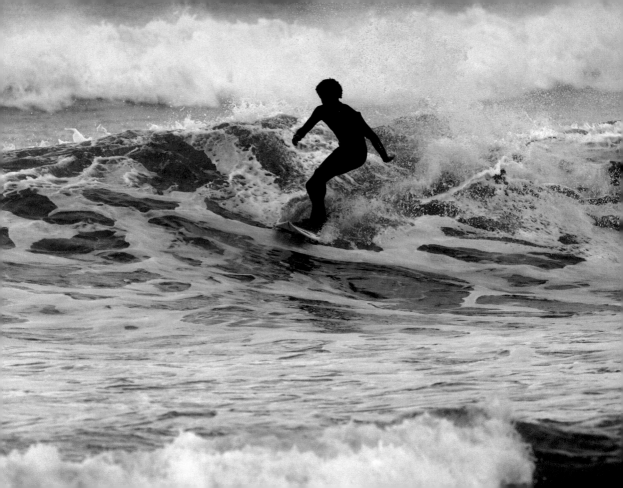

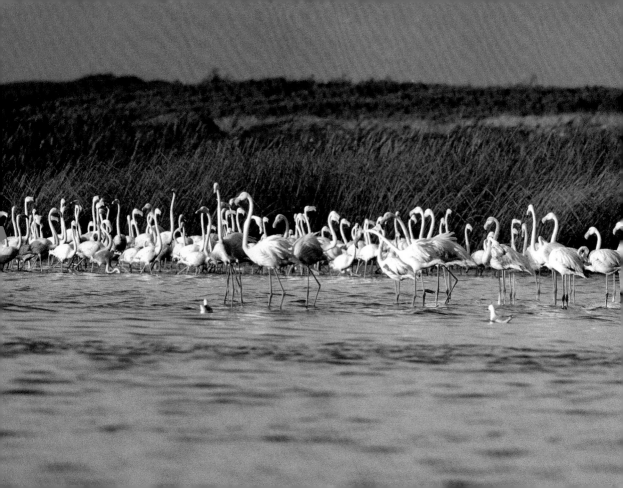

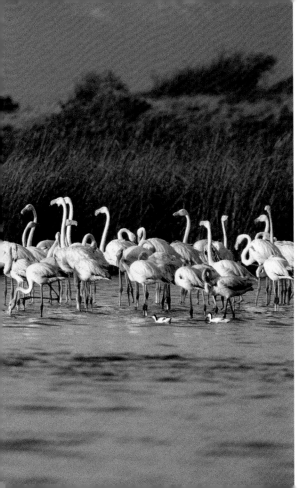

GATHERING AT THE WATER'S EDGE

A pink flock of lesser flamingoes (*Phoeniconaias minor*) gathers at the water's edge at Zeekoevlei near Muizenberg. This predominantly African bird is usually found on the shores of alkaline lakes where it feeds on blue-green algae, its main food source. When feeding, the bird holds its head and curved bill upside down under the water to scoop up algae and insect larvae from the muddy bottom. A complex filtration system in the bill ensures that large particles are excluded and the algae separated from the water. The water is expelled and the algae are transferred to the tongue and swallowed.

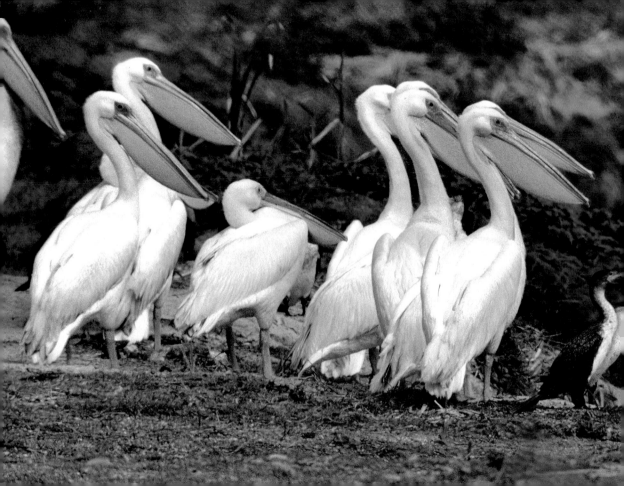

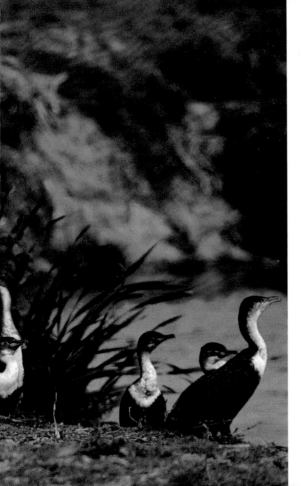

WHITE PELICANS AND WHITE-BREASTED CORMORANTS

A procession of white pelicans (*Pelecanus onocrotalus*), led by whitebreasted cormorants (*Phalacrocorax carbo*), waddles to the water at Zeekoevlei. When feeding, a pelican uses its large bill to scoop up fish and store them in the gular sac (pouch), which can hold more fish at a time than its stomach can. Though pelicans appear ungainly on land, they are particularly graceful in flight, soaring in a 'V' formation on thermal currents before descending in a spiral to rise again on another thermal. Pelicans occur throughout Africa, but are more likely to be seen near their regular breeding grounds, such as the Western Cape.

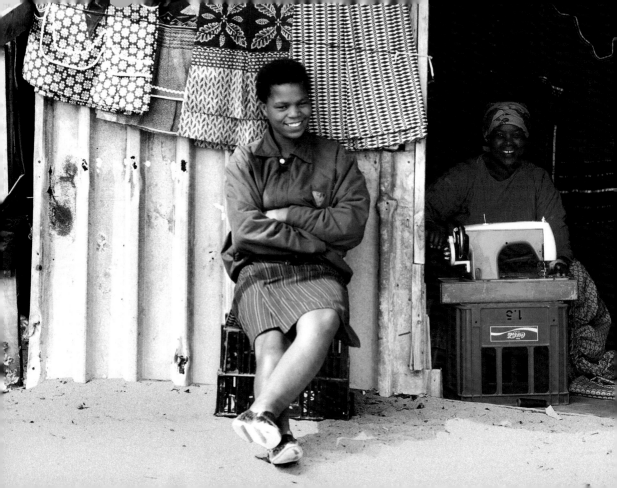

THE SPIRIT OF ENTERPRISE

Economic activity in the townships was generally discouraged by the authorities during the apartheid era, but since the change of government in 1994 business opportunities for those living on the fringes of the formal economy have been on the rise, as official policy now encourages the development of small- and medium-scale enterprises. Taking the gap, independent and creative entrepreneurs have surfaced in nearly all of Cape Town's informal settlements, and there is hardly a street that doesn't have its own spaza shop, often identified by rudimentary but colourful advertising signs. Prices are not always competitive, but paying them is preferable to taking a taxi to the nearest chain store, which can be up to 30 km away. In Khayelitsha, opposite the taxi rank, there is a buzz on the street where a row of spaza shops and hawkers' tables have sprung up. This stretch of businesses attracts hordes of commuters who make their way to and from the city each day by way of minibus taxis, an industry that also originated in the informal sector. The will to survive and a tenacity of spirit are what unites this ingenious breed of entrepreneurs.

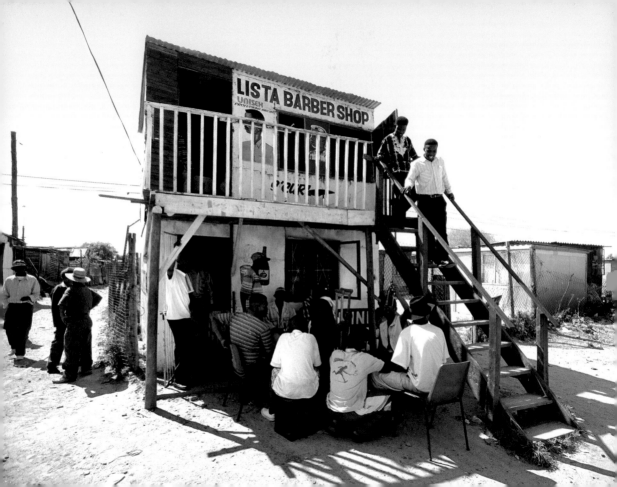

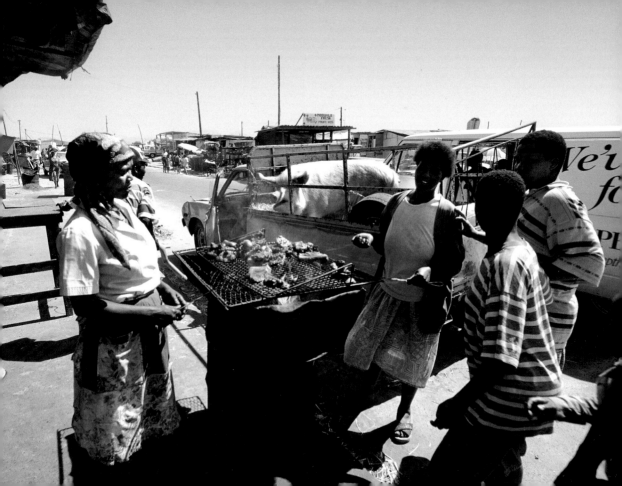

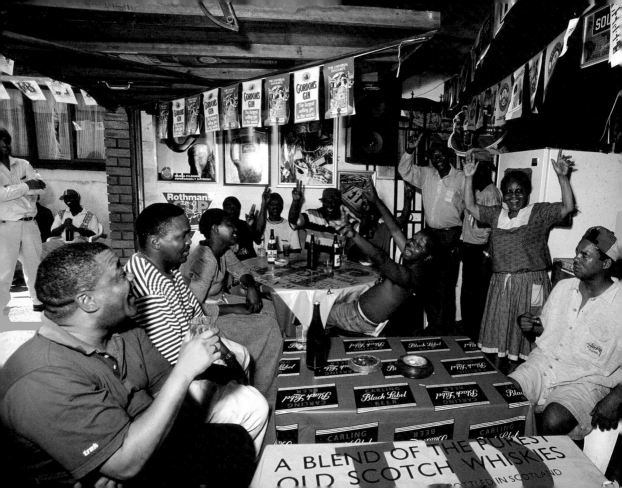

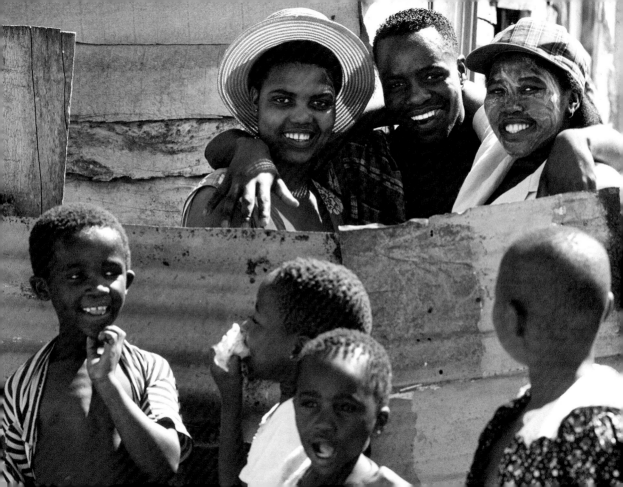

DISTRICT SIX – EARLY DAYS

District Six, established on the Zonnebloem estate, was first known as Kanala Dorp. The name is said to have derived from either the Dutch word for 'canal', of which there were many in Cape Town; or the old Malay word meaning 'to do a favour' – an evocative reference to the ethos that prevailed in this culturally diverse community. In 1867 the area was declared the sixth ward of the Cape Town Municipality and the name District Six was born. The earliest residents of Kanala Dorp were emancipated slaves, set free in 1836 under a British Act which declared the slave trade illegal throughout the empire. Its location close to the city and the harbour made District Six an attractive proposition for immigrants and locals alike. Soon, as the city expanded, many coloured people began to gravitate towards the new suburb. Jews from Lithuania and Latvia settled here, as did Indian, Italian, Greek and Portuguese immigrants, while migrant labourers from the Eastern Cape added an indigenous flavour to the heady mix of cultures and traditions that fired the soul of District Six.

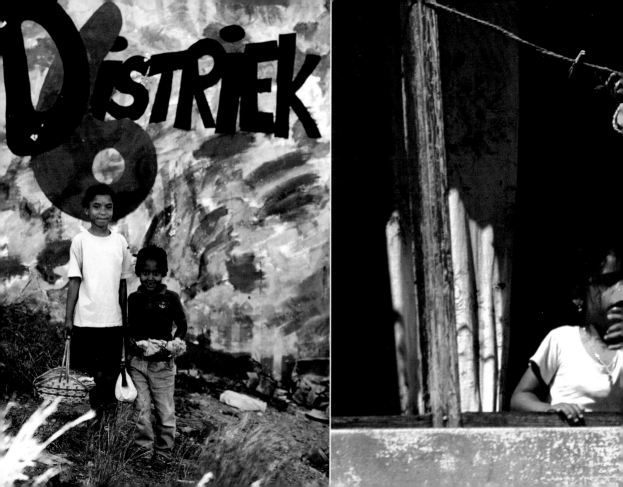

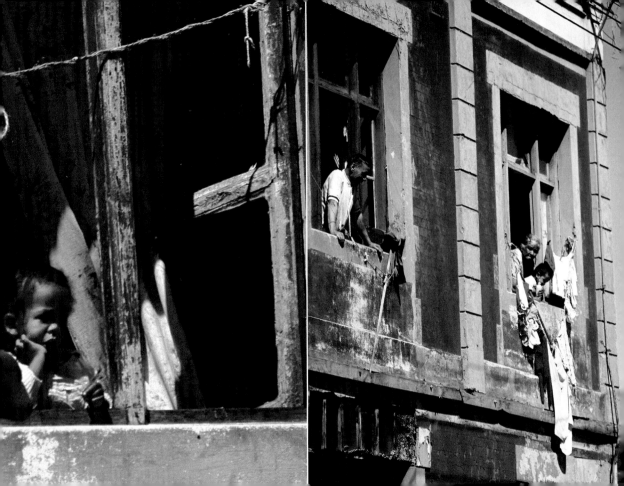

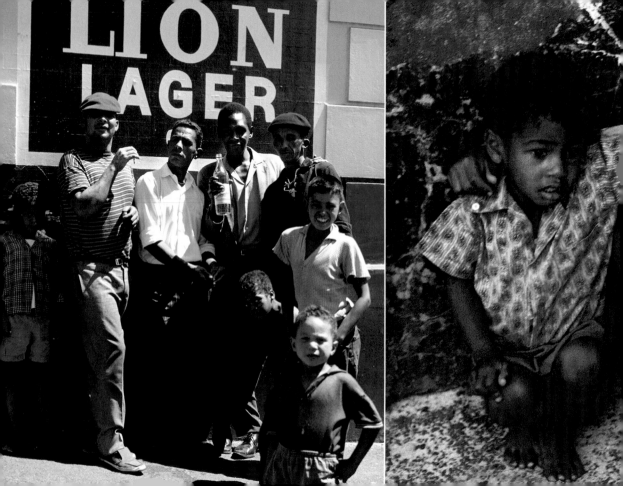

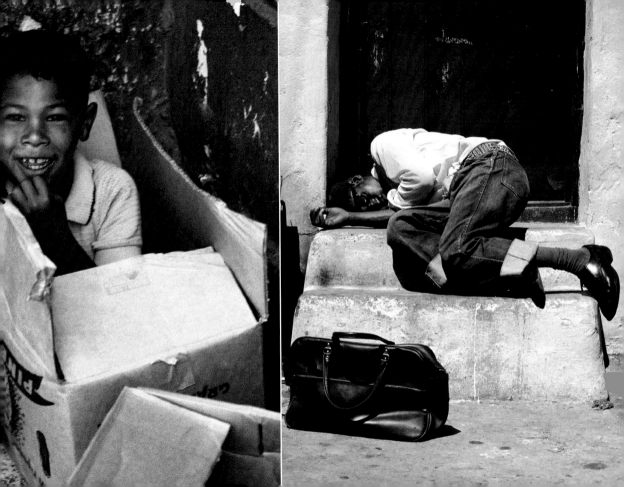

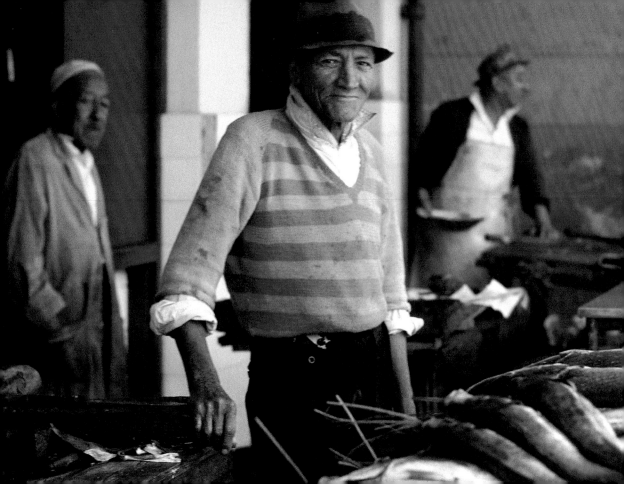

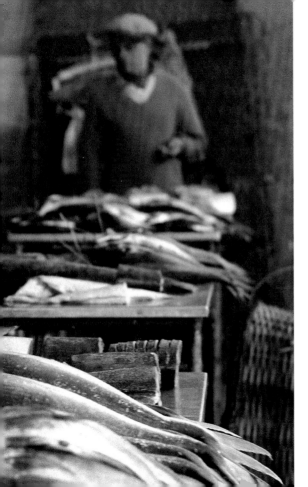

DISTRICT SIX AND THE FISHING INDUSTRY

Fishing was a main source of livelihood for many living in District Six; the fishmongers and fish hawkers were a central part of the district's daily commerce. The fish market in Hanover Street, divided into stalls from which fishmongers could sell the catch of the day, opened in 1937. It replaced the Dock Road fish market in Roggebaai, which, like the fishing community there, had earlier been displaced by the encroaching fishing industry. By the turn of the century most of the Roggebaai fishing families had moved to either District Six or the Malay Quarter.

HANOVER STREET

The heart of District Six could be found in Hanover Street. Here, in an atmosphere of goodwill, every need was catered for, every whim attended to. A wide range of household goods could be bought at W. Stern's The Little Wonder Store (Direct Importers) at 101 Hanover Street, while further down the road Salie Dollie's Chemist Shop sold herbal remedies that could cure almost any ailment. For 50 cents the Westminster Restaurant would fill a customer's cooking pot with the most delicious Malay curry in town. For those desperately out of pocket, the *smeerwinkels* (general dealer shops) would sell small quantities of peanut butter, jam or cheese, wiped onto paper. Then there was the famous fish market, where customers clamoured for freshly caught snoek, yellowtail or harder (mullet). Just around the corner were the public baths, frequented by residents whose homes had no bathrooms. For a tickey (2.5 cents) patrons could buy a hot bath or shower, and, at no extra cost, catch up with local gossip. Hanover Street has been revered in song, its memory captured in plays; but its soul will forever be engraved on the hearts of those whose lives were shaped by the events that took place in this lively street.

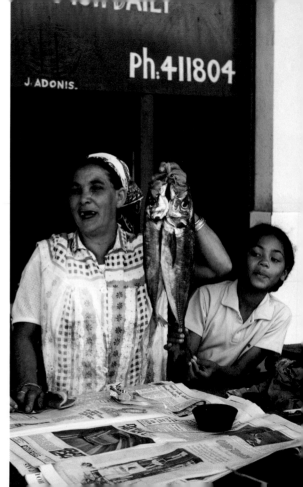

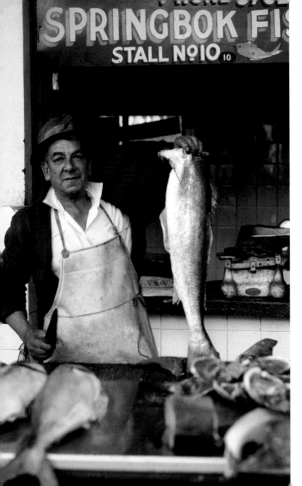

DISTRICT SIX FISH MARKET

Together with the Hanover Street Wash House, the fish market was one of the last remaining buildings in District Six. Both these buildings were finally demolished in the late 1970s. The fame of the fish market spread far and wide as Capetonians from all walks of life descended on the cubicled building on the corner of Hanover and Muir Streets to buy the freshest of the day's catch.

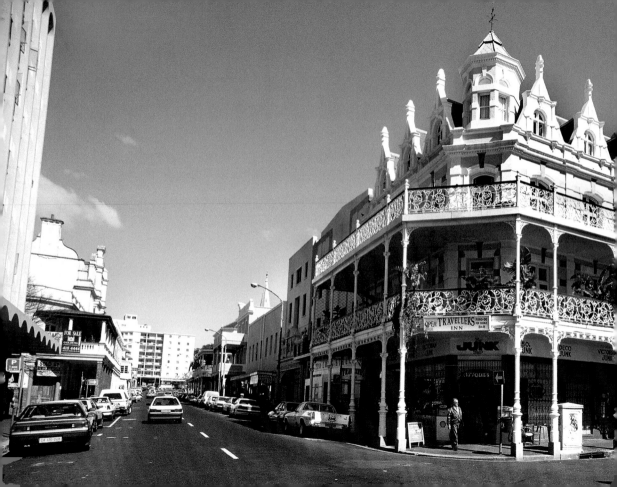

SHOPPING IN LONG STREET

Sassy and irresistible, Long Street has a life all of its own. Its shops are a blend of the old and the new, the charming and the brash, the overstated and the undiscovered. Browse around its cavernous bookshops where the anticipation of hidden treasures hangs in the air like the musty smell of ancient books. Darkly lit shops selling vintage clothes rub shoulders with purveyors of high fashion and street fashion. Junk shops and antique shops abound, as do daytime restaurants and late-night eateries. Driven by a generous heart, Long Street is a life-giving force right in the heart of the Mother City.

BROEKIE LACE

An infinite variety of ornate cast-iron railings, known as 'broekie lace', adorns the balconies of the many Victorian buildings in historic Cape Town. Cast-iron goods, mass produced following the advent of the industrial revolution during the mid-nineteenth century, could be ordered from illustrated catalogues displaying detailed drawings of castings. Customers, many of them architects, could choose goods ranging from lamp brackets to drinking-fountains, bathroom fixtures to firegrates, entrance gates to bandstands. But the largest part of any catalogue was devoted to veranda poles, decorative railings and lacy brackets, all of which are in evidence in Long Street. Cast-iron suppliers were to be found in Scotland and the English Midlands, and today the products of these foundries can be seen in major cities across the world.

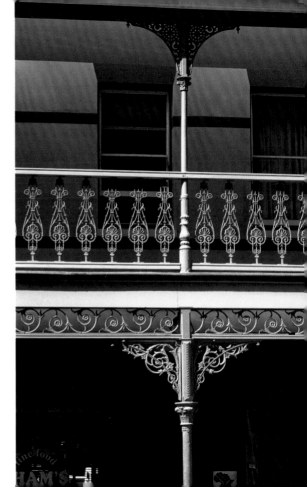

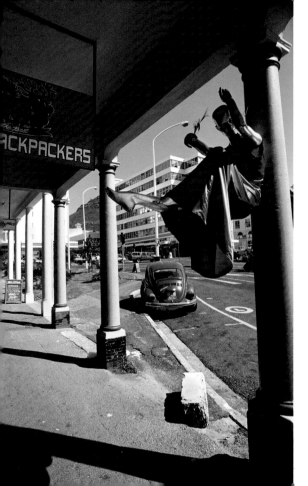

LONG STREET –
A BACKPACKERS' HEAVEN

A metallic painted mannequin floats above street level, silently beckoning travellers to try the hospitality of one of the many lodges in Long Street. This street's latest renaissance as a backpackers' mecca has added a rich, cosmopolitan dimension to an already trendsetting precinct.

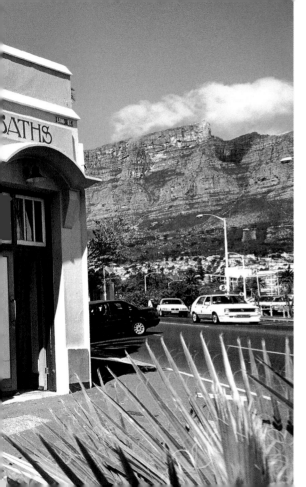

LONG STREET BATHS

The Corporation Swimming Baths, as the Long Street Baths were originally called, were opened by the mayor, Councillor Fred W. Smith JP, on 4 November 1908. The Turkish steam baths and public slipper baths were added in 1928 after a five-year campaign by Councillor Sam Goldstein, who believed that no modern city should be without such an amenity. In 1985 the city council decided to renovate the baths; the beautifully restored Long Street Baths have retained the Edwardian character and art nouveau details of the original buildings. They are still much used by Capetonians and tourists alike, with separate days for men and women at the Turkish baths.

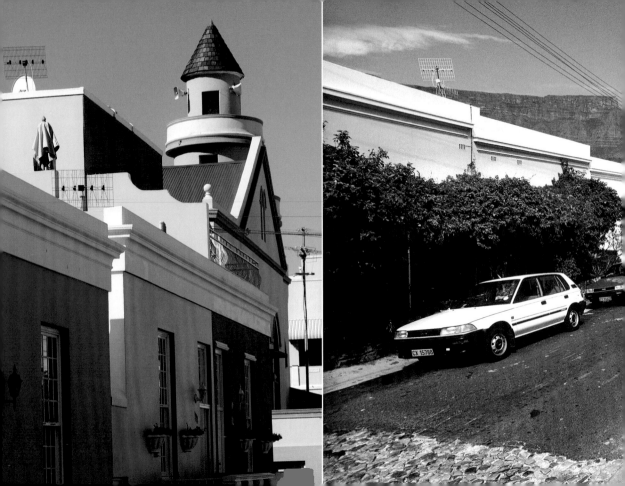

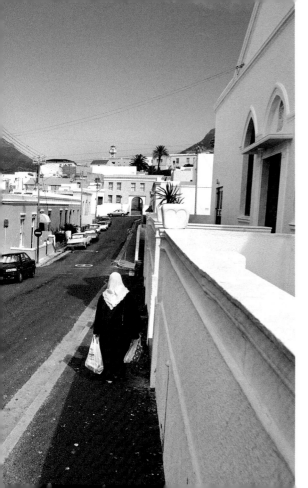

THE BO-KAAP

Above the city, on the slopes of Signal Hill, lies the Bo-Kaap. Originally known as Waalendorp, the first homes were built in the 1760s and rented by artisans and craftsmen of European descent. The influx of Muslims to the area coincided with the building of the Bo-Kaap's first mosque, the Auwal Mosque, in 1795. Its founder, Tuan Guru, came to the Cape as a political prisoner from Tidore in Indonesia in 1780. By 1840, several mosques had been built in the Bo-Kaap and, after the emancipation of the slaves in 1834, many Muslims chose to settle near their places of worship.

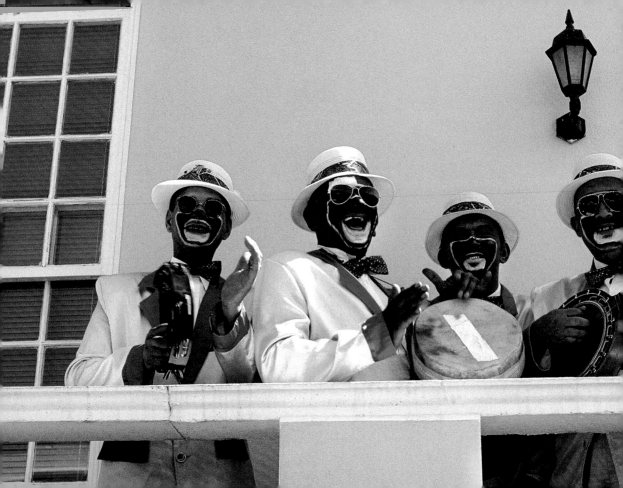

CAPE CARNIVAL

The Cape Minstrel Carnival has its roots in the music and dance style of North American minstrel groups who visited the Cape in the late 1880s. The first three days of the new year is carnival time: Cape Town's streets are transformed into a kaleidoscope of colour, as the *Kaapse Klopse* (minstrels) cavort through the city, singing new and old *moppies* (humorous songs) and dancing to the sounds of banjos, tubas, guitars, guma drums and whistles. The partying lasts for days, and the festivities for a month. January is devoted to contests held at the Green Point and Athlone stadiums where performance clubs compete for various trophies.

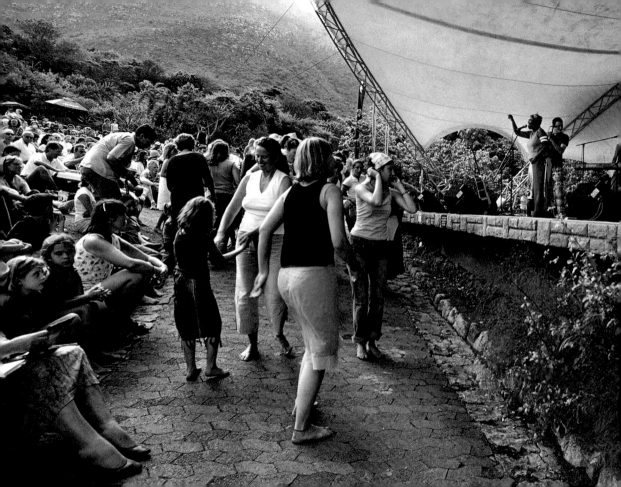

ROCKING IN THE GARDENS

On summer Sundays locals and visitors descend on the Kirstenbosch National Botanical Garden for the popular Summer Sunset Concerts. Introduced in 1992, the concerts have become a permanent fixture on the city's social calendar, attracting up to 40,000 people between December and March each year. Young and old come to sit on the verdant lawns, nibble on snacks and quaff wine while listening to the best of local music. Those who have performed here include divas Miriam Makeba and Tina Schouw, jazz favourites Jimmy Dludlu and Robbie Jansen, rock group Sons of Trout and the ever-popular blues outfit, the Blues Broers. The concerts raise over R1 million per year for the garden.

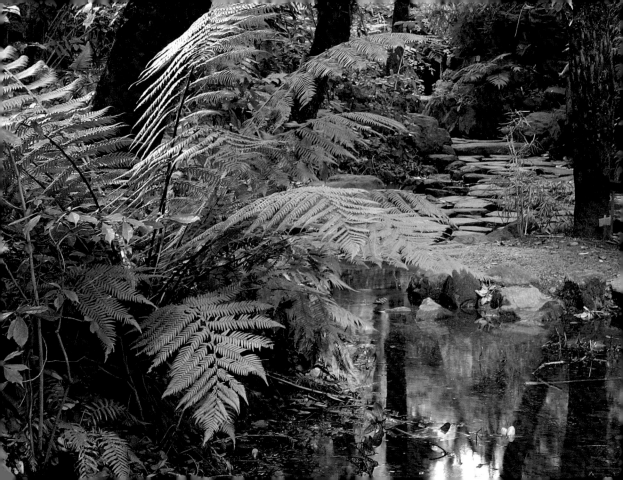

KIRSTENBOSCH NATIONAL BOTANICAL GARDEN

Kirstenbosch, on the eastern slopes of Table Mountain, overlooks False Bay and the Cape Flats. The gardens are devoted mainly to indigenous plants; although most are from the winter rainfall region, there are also many hardy species from elsewhere in the country. The thoughtfully laid out gardens include a fragrance garden, a braille trail and sections planted with cycads, aloes, euphorbias, ericas and proteas. A special section contains 'muti' plants, used by traditional healers (*sangomas*).

COLONEL BIRD'S BATH *(overleaf)*

This bird-shaped pool, filled with crystal-clearwater, was built in 1811 by Colonel Christopher Bird, who was then the owner of the upper section of Kirstenbosch. The pool is built where four springs meet and is known as Colonel Bird's Bath, althoughit is sometimes erroneously referred to as Lady Anne Barnard's Bath – the Barnards owned a country house nearby, but left the Cape in 1802, before the bath was built.

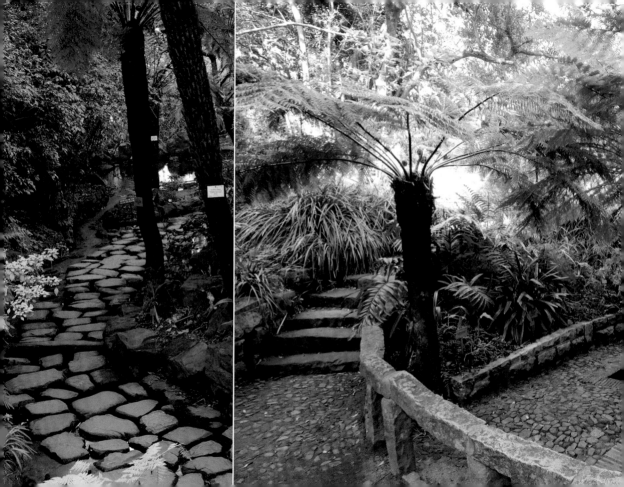

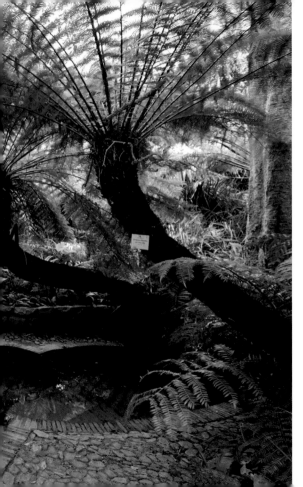

EARLY KIRSTENBOSCH

The area that is now Kirstenbosch National Botanical Garden once contained an indigenous forest of yellowwood and silver trees. In 1660 Jan van Riebeeck planted a bitter almond hedge on the boundary of the Dutch East India Company land, to keep the cattle in and the Khoikhoi, who came over Constantia Nek from Hout Bay to rustle them, out. He also felled many trees for shipbuilding and other construction work. Farmers grazed their cattle where the trees had been cut down. In 1795 the land was bought by J.F. Kirsten, after whom it is named. In 1853 Hendrik Cloete (owner of Groot Constantia) inherited Kirstenbosch. He continued the work of clearing indigenous trees and planting vineyards and oaks. In 1895 Cecil Rhodes bought Kirstenbosch and planted camphor trees, gums and pines. On Rhodes' death in 1902 Kirstenbosch was left to the nation, and in 1913 it was officially declared a national botanical garden.

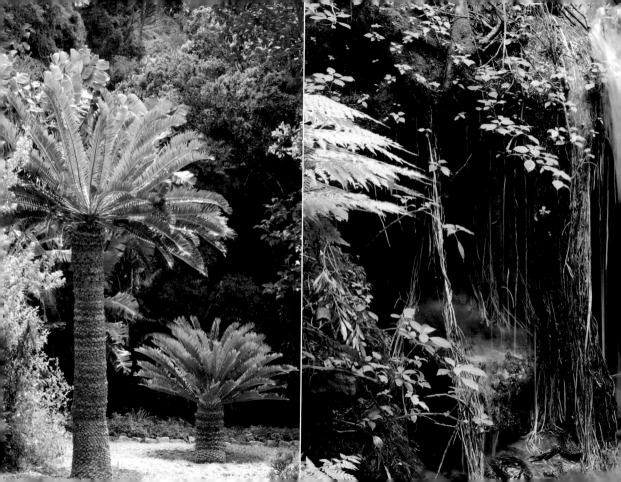

PLANT KINGDOMS

The indigenous plants of Kirstenbosch straddle two of the six plant kingdoms of the world, the Palaeotropical floral kingdom, which includes the plants of most of sub-Saharan Africa, and the Cape floral kingdom, the smallest plant kingdom, incorporating plants from the Cape's winter rainfall region. There are 8,500 species in the Cape floral kingdom, and the Cape Peninsula has 2,600 of these, which are divided into fynbos and evergreen forest. The first directors of Kirstenbosch tried to recreate the landscape that existed before the tree felling, cattle grazing, wine growing and importation of alien trees that began with the arrival of Europeans.

THE LESSER DOUBLECOLLARED SUNBIRD

The lesser doublecollared sunbird *(Nectarinia chalybea)* is a common inhabitant of mountains, forests and urban gardens in the Western Cape and along the eastern coast. It appears inland in Gauteng, and may venture into the Karoo and the interior in years of good rainfall. As with all sunbirds, the slender, curved bill of the lesser doublecollared sunbird is uniquely adapted to reach deep within flowers, such as the tubular-shaped ericas. The bird moves its long, forked tongue in and out of its curved beak to draw up nectar. If it is unable to reach the nectar, the sunbird will pierce the base of the flower. Sunbirds also prey on spiders and insects, which they catch on the wing.

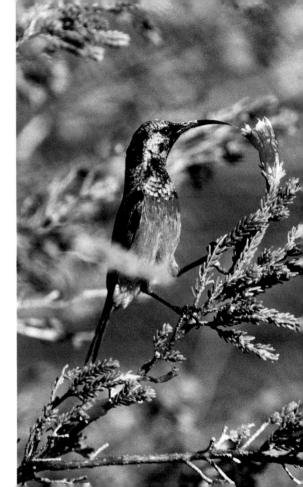

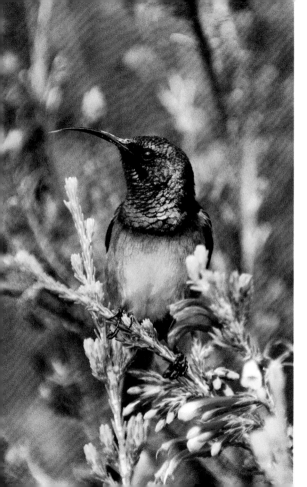

THE ORANGEBREASTED SUNBIRD

This tiny sunbird (*Nectarinia violacea*) is found only in a small area of south-western and southern South Africa, mainly in mountainous areas where the natural vegetation has remained undisturbed. The male is iridescent, while the female has an overall greenish-yellow colour. The orangebreasted sunbird enjoys a symbiotic relationship with ericas and proteas, part of the Cape's rich flora, which it pollinates as it moves from flower to flower. Gregarious, except when breeding, these sunbirds are sometimes found in flocks of up to a hundred birds at a time.

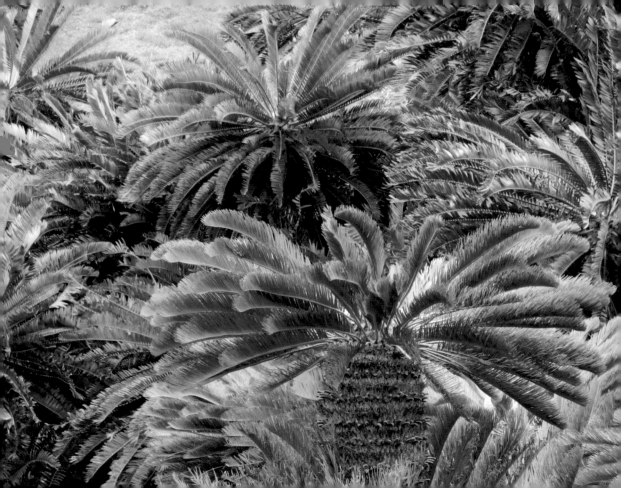

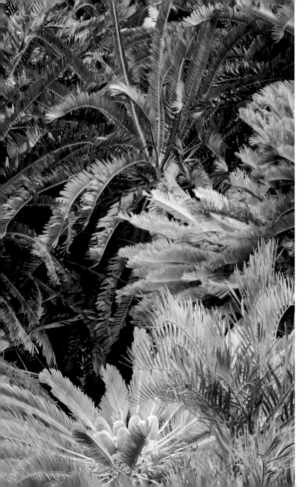

CYCADS

The grove of cycads found near Colonel Bird's Bath, in the lower region of Kirstenbosch National Botanical Garden, was planted by Professor Harold Pearson, the garden's first director. He collected 500 specimens from other parts of the country, mainly the Eastern Cape. Planted from 1913 onwards, the cycad section is Kirstenbosch's oldest living plant collection, with some of the plants estimated to be 1,000 years old. Cycads are dioecious, bearing male and female cones on separate plants. Grouped in an amphitheatre in the gardens, the collection is evocative of a prehistoric era when cycads added splendour to a verdant plant kingdom.

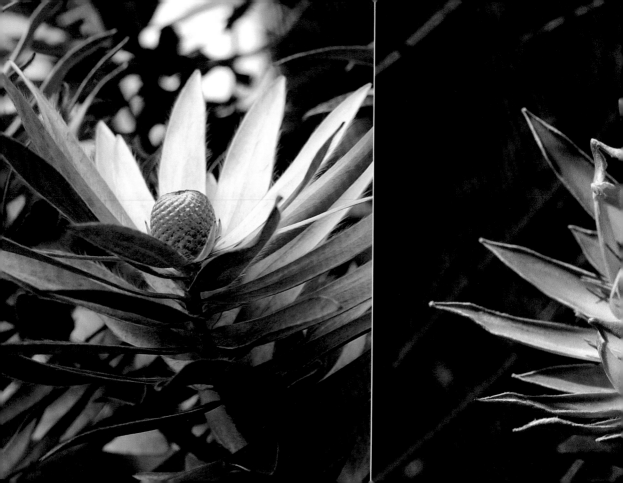

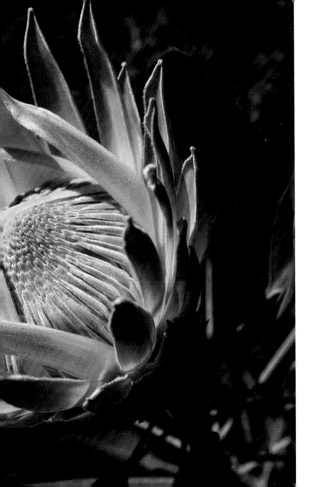

THE SILVER TREE

The splendid silver tree (*Leucadendron argenteum*) is found in its natural environment only on south-western Cape mountains. Although the trees can appear dull in winter, they come into their own during the summer months, with the dense, silky hairs on their leaves glistening like the tree's namesake in the sunlight. Initially classified as *Protea argentea* by the great taxonomist Carl Linnaeus in 1753, the silver tree was the first to carry the name 'protea'.

THE KING PROTEA

Beautiful and regal, the king protea (*Protea cynaroides*) is South Africa's national floral emblem. Its compound flower head consists of an involucre (cup) of coloured sterile bracts, enclosing between 250 and 600 individual flowers. The king protea can grow to 2 m high, and the flower head can measure up to 30 cm across. Common on mountains ranging from the Cederberg to Grahamstown, the king protea is found at different altitudes and in diverse habitats. In every locality the plants consist of distinct variants, each genetically programmed to flower at different times of the year.

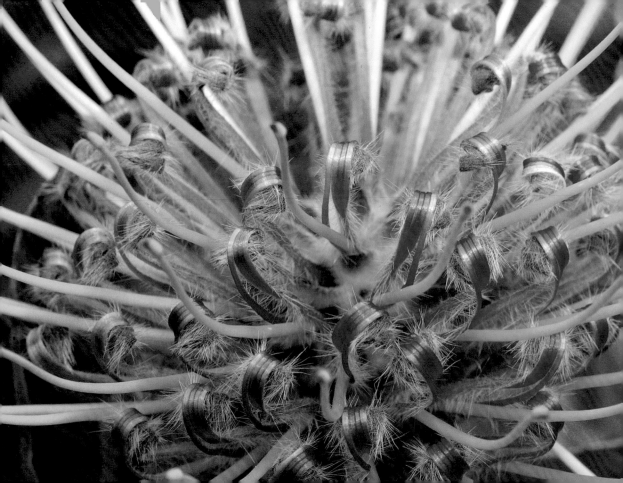

THE SCARLET RIBBON PINCUSHION

The scarlet ribbon pincushion *(Leucospermum hybrid)*, part of the protea family, is a hybrid of two natural species. It occurs throughout the south-western Cape. There are two distinct phases in the flowering cycle of the pincushion. The first is characterised by the pincushion shape, while in the second the flower opens to display splendid tightly coiled perianths and long, scarlet styles which spread horizontally as the flower ages.

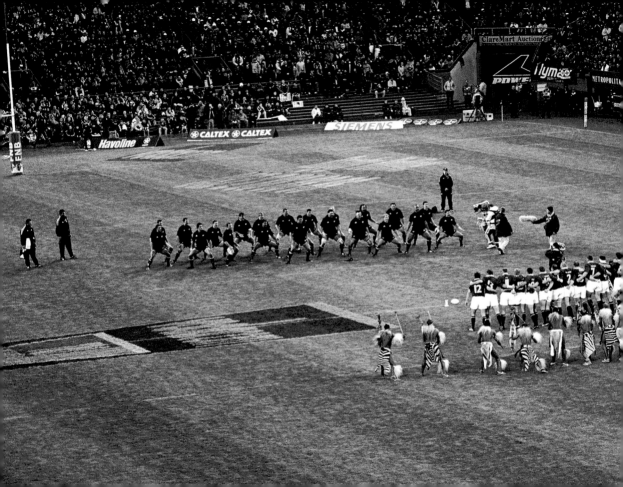

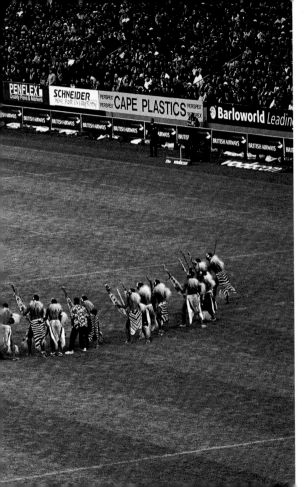

RUGBY AT NEWLANDS

Rugby, along with soccer and cricket, occupies pride of place in the heart of a sports-mad nation. In Cape Town the 'Newlands faithful' come from all over the city to cheer for the home team, Western Province. But when international matches are played, it is the Springbok team, with their green-and-gold jerseys, that elicits wild cheers from the crowd. On such occasions nothing can stand in the players' way, not even New Zealand's All Blacks, whose war cry, the Haka, has been known to intimidate some players. And even if the hosts concede a few points, the home team's fans – knowledgeable, loyal and fiercely partisan – are behind them all the way.

CECILIA FOREST

A mountain stream cascades down moss-covered rocks in a progression of miniature waterfalls. In the kloof, ferns and undergrowth flourish on the moist forest floor, protected from harsh sunlight by a delicate veil of treetop leaves. The mountains of the Cape Peninsula offer nature lovers an idyllic escape from the turmoil of city life.

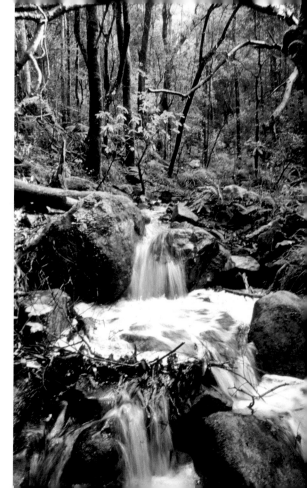

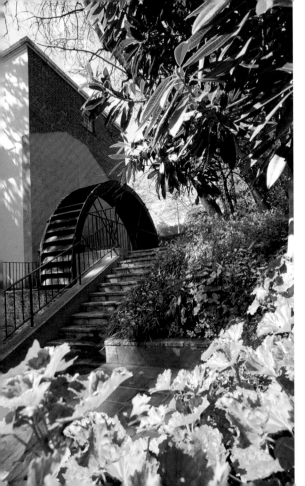

JOSEPHINE MILL

Situated on the banks of the Liesbeek River in Newlands, the Josephine Mill is Cape Town's only surviving and operational watermill. The first watermill was erected on the site by Johannes Frederick Dreyer in 1818, and his widow, Maria, employed and later married Jacob Letterstedt, a Swede who had fled from his debts in Stockholm. He renamed the farm Mariendahl, after his wife, and established a brewery, expanding the farm and mill to the point where, in 1837, he could return to his homeland and pay his creditors. The high point of his visit was an audience with Crown Princess Josephine, after whom he named his new, im-proved mill in 1840. When he died in 1862 the mill, brewery and other properties were inherited by his daughter, Lydia, who added a five-storey section to the mill when she converted it to steam power in the 1880s. A neighbour and fellow Swede, Anders Ohlsson, added Mariendahl and Josephine Mill to his Newlands valley brewing monopoly, which eventually became South African Breweries, now the fourth-largest producer of beer in the world. The mill ceased operating in 1896, and eventually fell into ruin. It was donated to the Historical Society of Cape Town in 1975, and restored over a 13-year period.

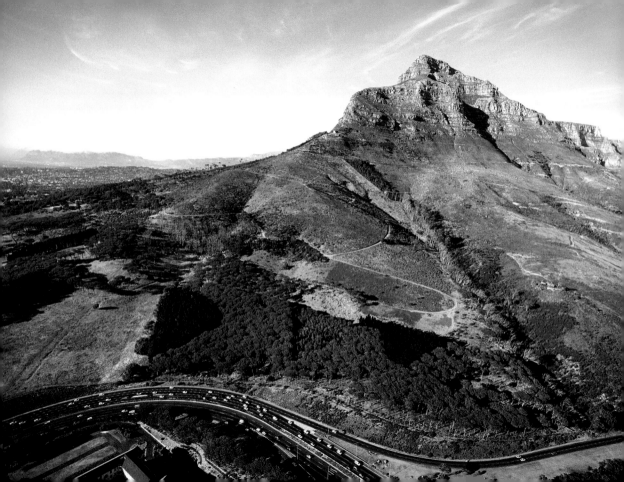

MOSTERT'S MILL

The oldest surviving windmill in South Africa, Mostert's Mill, was built in 1796 on Welgelegen, the farm of Gysbert van Reenen. Communal mills, where farmers could grind their wheat, were controlled by the Dutch East India Company, and Van Reenen had to obtain special permission for the construction of his privately owned mill. The mill was named after Van Reenen's son-in-law, Sybrand Mostert, who inherited Welgelegen after the death of Van Reenen. Overtaken by modern technology, Mostert's Mill fell into disuse in the latter half of the nineteenth century. In the 1930s the South African government commissioned a millwright from Holland to restore it to working order. Mostert's Mill is situated at the top end of Mowbray and can be viewed from Rhodes Drive.

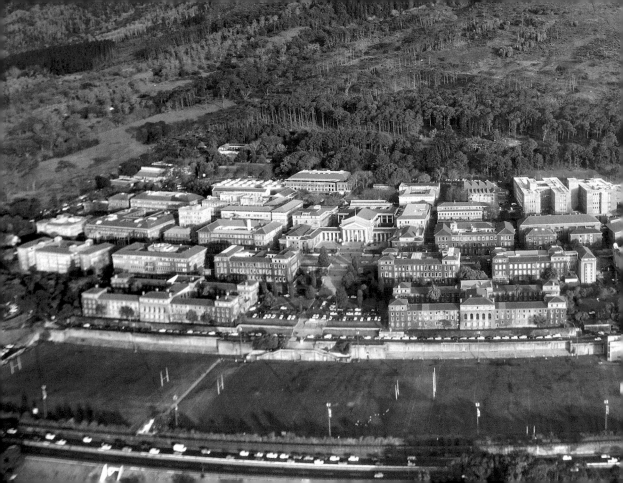

THE UNIVERSITY OF CAPE TOWN

The University of Cape Town, on the slopes of Devil's Peak, is renowned for academic and research excellence. Established in 1829 as the South African College, it attained university status in 1918. In 1928 the university moved from Hiddingh Hall in Government Avenue in the Gardens to the Groote Schuur campus, part of Cecil John Rhodes' Groote Schuur bequest. The new campus was designed by J.M. Solomon, and the project completed by Hawke & McKinlay and a young Baker protégé, C.P. Walgate. They modified Solomon's drawings, retaining the Oxbridge-style quadrangles of the residences, but aligning the buildings along the contour of the mountain.

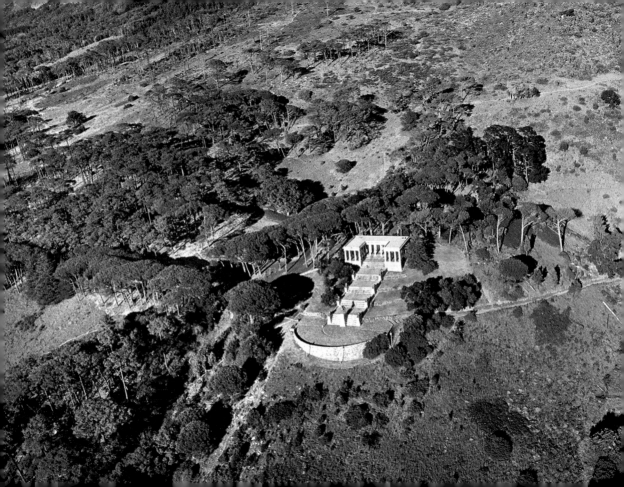

THE RHODES MEMORIAL

Cecil John Rhodes purchased an estate on the eastern slopes of Table Mountain, hoping to preserve the area for the nation. In 1912 the north-facing Rhodes Memorial was built, reflecting Rhodes' desire to make Africa British 'from the Cape to Cairo'. The classically styled memorial was designed by Herbert Baker and Francis Masey and built from Table Mountain granite. The eight large bronze lions flanking the stairway and a bust of Rhodes are the work of J.M. Swan, while a bronze statue of a prancing horse called Physical Energy was donated by the sculptor, G.F. Watts. The original cast is in Hyde Park in London.

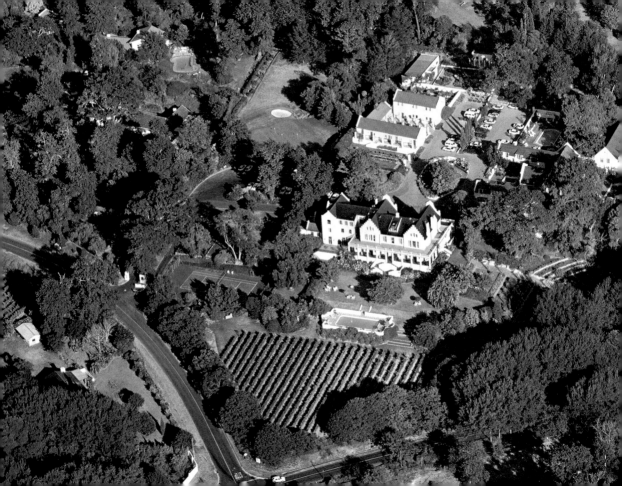

THE CELLARS-HOHENHORT

The Cellars-Hohenhort Hotel in the Constantia valley comprises the magnificently restored wine cellars of the seventeenth-century Claasenbosch estate, and the Hohenhort manor house of Wilhelm Spilhaus, a German immigrant and silverware trader. Spilhaus bought part of the estate in 1906 and commissioned the architect E. Seeliger, to build a spacious family home. Today the Cellars-Hohenhort is regarded as one of the world's premier hotels. Camphor trees, imported from Japan in the late seventeenth century, line the entrance avenue; and the garden with its rose bushes, oaks and lotus flowers is a sanctuary for the soul.

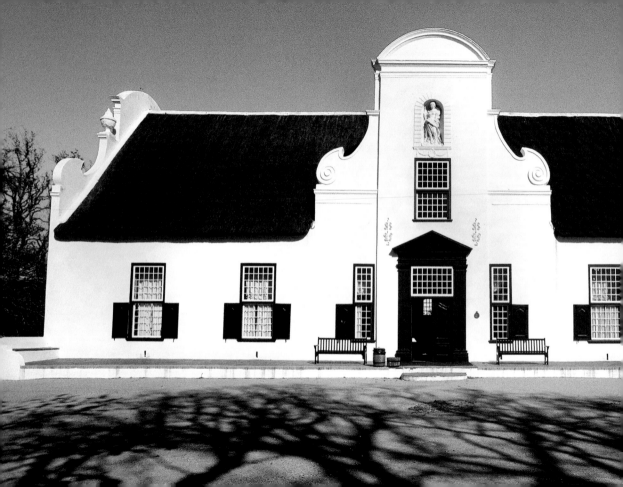

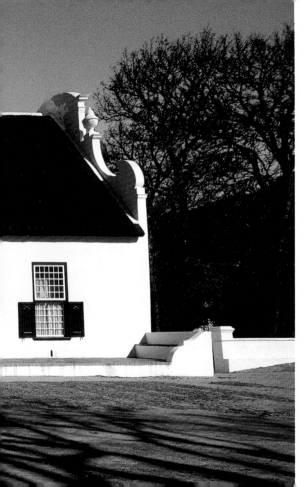

GROOT CONSTANTIA

Simon van der Stel arrived from the Netherlands in 1679 to become governor of the Cape of Good Hope. A keen agriculturalist, he requested land for the establishment of a farm on which to experiment with crops and farming methods suitable to the Cape. In 1685, on the recommendation of a high official of the Dutch East India Company, Rijckloff van Goens, Van der Stel was given permission to live away from the Castle. He went to great lengths in selecting a site for his farm, ordering baskets of earth from the land between Table Bay and Muizenberg to be brought to the Castle for testing, and eventually selecting about 800 ha of the most fertile land behind Table Mountain. Here he planted fruit trees, olive trees and a variety of grapes. After his death in 1712, Constantia was subdivided and sold, and the farm fell into a state of ruin. The estate was rescued when Hendrik Cloete bought it in 1778. In 1791, Cloete employed Louis Thibault and Anton Anreith to renovate the original homestead and build a new wine cellar. The cellar was built above ground, with thick walls to keep the wine cool, but was somewhat unusual in having two storeys. The neo-classical pediment is adorned with a finely sculpted Bacchanalian allegory in Baroque-rococo style by Anreith.

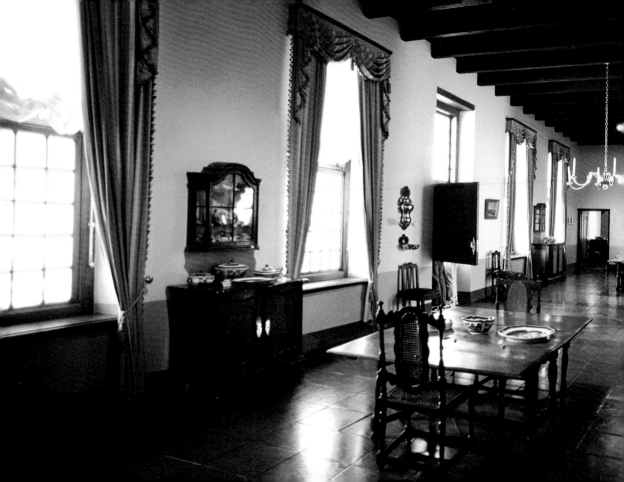

INSIDE GROOT CONSTANTIA

In 1925 the Groot Constantia homestead burnt down, leaving only the walls standing. The building was restored under the chairmanship of architect F.K. Kendall, after which it was turned into a museum. The shipping magnate and philanthropist Alfred de Pass offered to furnish the homestead at his own expense. The museum interior is reminiscent of a Cape Dutch farm in the 1800s, containing a priceless collection of Cape Dutch furniture, Chinese, Japanese and Delft porcelain, pottery and mainly Dutch and local paintings.

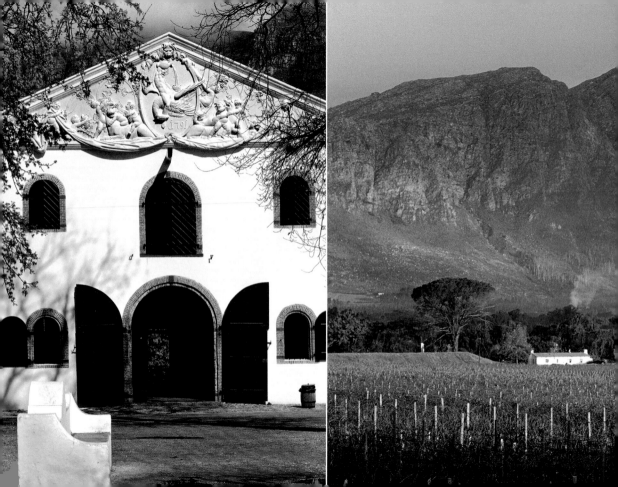

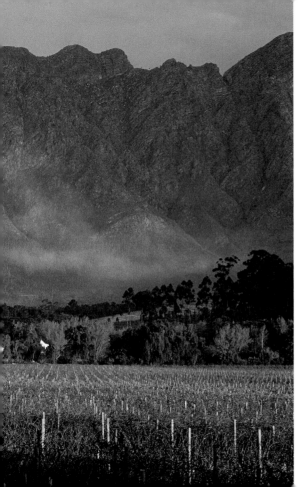

THE CAPE WINELANDS

The first vines of the Cape were planted in the Company's Garden by Jan van Riebeeck in 1655. Four years later the first grapes were pressed, and the settlement began to supply passing ships with wine, vinegar and brandy. The next governor, Simon van der Stel, encouraged the expansion of the Cape wine industry, and wine-farming settlements were established in the Stellenbosch and Franschhoek valleys outside Cape Town. The export of Cape wines grew rapidly after 1813 when Britain reduced the duty payable on the importation of Cape wines. By 1822 wines from the Cape Colony accounted for 10 per cent of wine consumed in Britain.

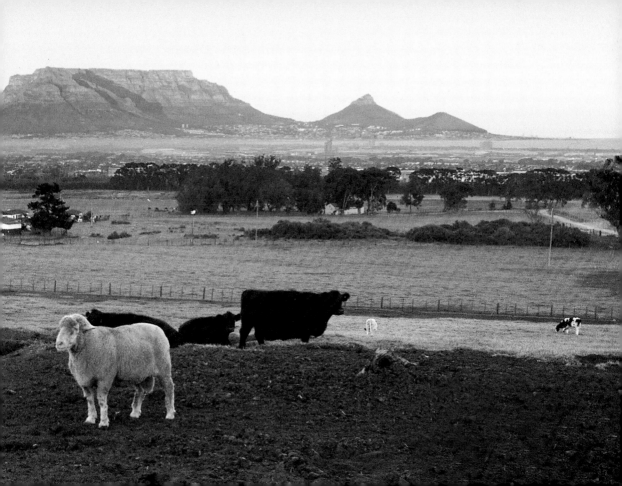

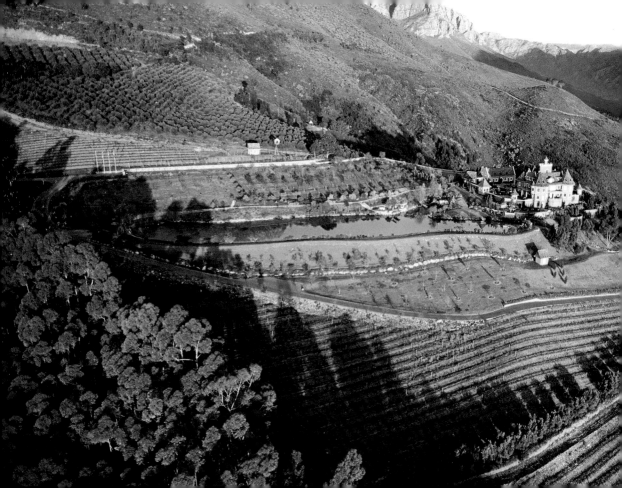

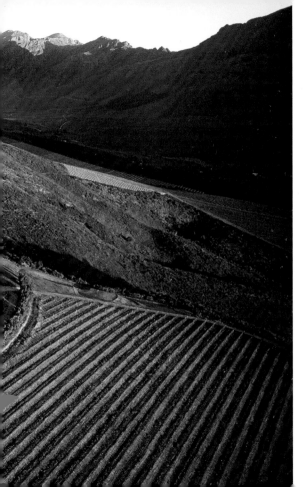

THE CAPE WINE INDUSTRY

High up on a Stellenbosch hill, a turreted castle overlooks a valley of freshly planted vineyards. Having emerged from years of isolation, the Cape wine industry has cultivated a dedicated international following. Popular Cape reds are cabernet sauvignon and pinotage, the latter a unique Cape hybrid of pinot noir and hermitage. The rising stars among Cape white wines are the sauvignon blancs; some good chardonnays are also available. An iced glass of muscadel or hanepoot – sweet fortified wines in the great Cape tradition – is a perfect way of rounding off a meal.

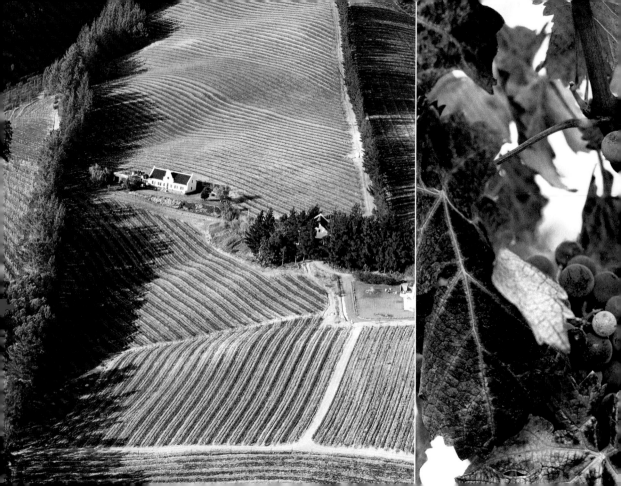

FRANSCHHOEK

A dense row of pine trees casts long shadows over gently sloping hills where a lone homestead basks in the late afternoon sun. Embraced by mountains and covered with vineyards, Franschhoek (meaning French corner) is one of the Cape's most spectacular valleys. The district was settled in 1688 by French Protestant refugees who had fled religious persecution in Europe. Bringing with them expertise in agriculture and wine-making, the French Huguenots laid the foundation for a 300-year-old tradition of viticultural excellence in this corner of the Drakenstein valley. When the British took control of the Cape in 1806, Franschhoek was producing two-thirds of the colony's wine, leading the British to mistakenly credit the Huguenots with the introduction of vines at the Cape. The nine original farms granted to the Huguenot settlers are still associated with wine-making, and some of these continue to reap top honours for their wines.

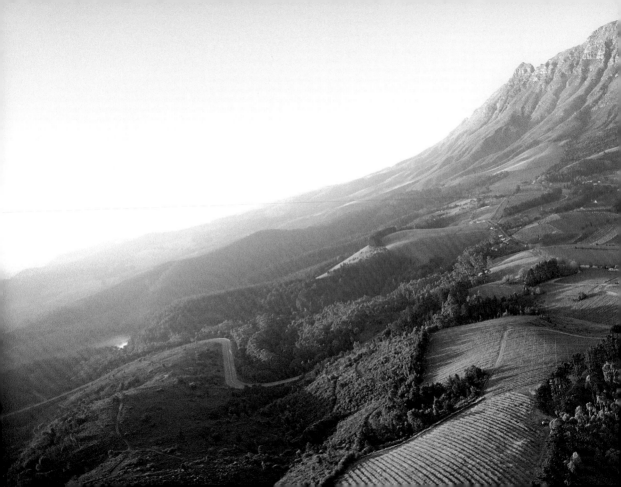

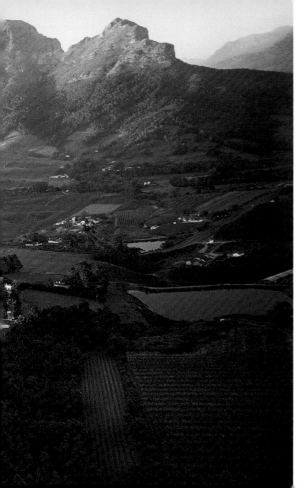

HELSHOOGTE PASS

Dusk settles on the rolling hills and towering peaks of the Simonsberg mountain. A winding road meanders through forests and vineyards to reach the wine route estates situated along the precipitous Helshoogte Pass. The first wine route to showcase and sell estate wines was begun in 1971, in Stellenbosch. Since then, wine routes have sprung up in most wine-growing districts in the Cape, allowing aficionados to visit farms as far afield as the west coast and Worcester. A winelands tour can be combined with lunch at one of the excellent farm restaurants, a cellar tour, or a visit to some of the beautiful old Cape Dutch farmsteads.

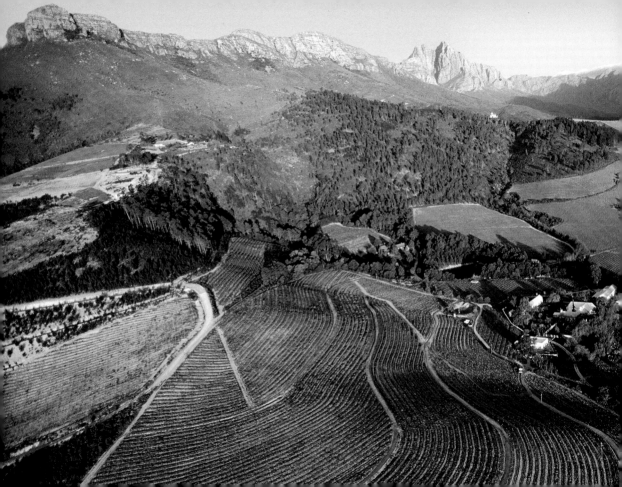

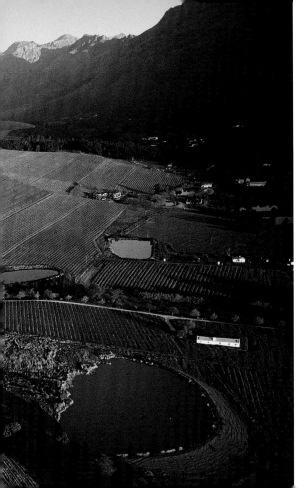

STELLENBOSCH

Neatly planted rows of vines grace the contours of the Stellenbosch hillside. A 40-minute drive from Cape Town, Stellenbosch, the second-oldest proclaimed town in South Africa, boasts a variety of red and white wines from award-winning wine estates and co-operative wine cellars. Situated in the valley of the Eerste River (literally 'first river'), the town was established in 1679 by Simon van der Stel, who granted farms and vine stocks to free burghers and colonists from Holland, France and Germany. Wine-growing took off when the first harvests proved that the district's fertile soils and diverse climates were ideal for the cultivation of vineyards.

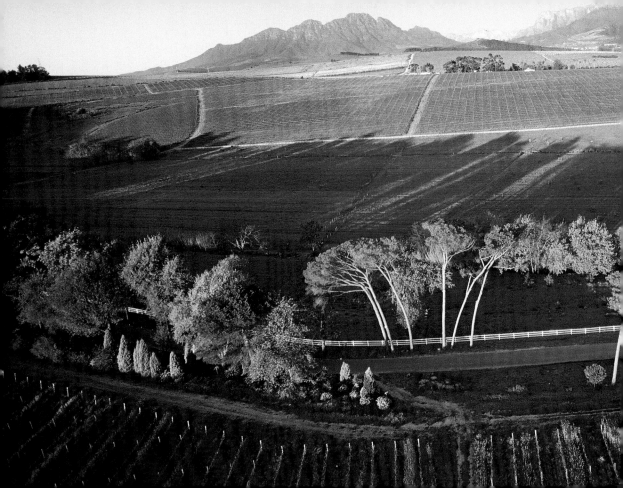

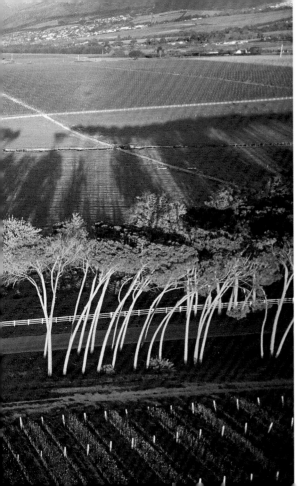

NEETHLINGSHOF

The setting sun casts dark-green shadows over a luminescent landscape dominated by the famous Pine Avenue of the Neethlingshof estate. In the distance, towering mountain peaks create a jagged skyline.

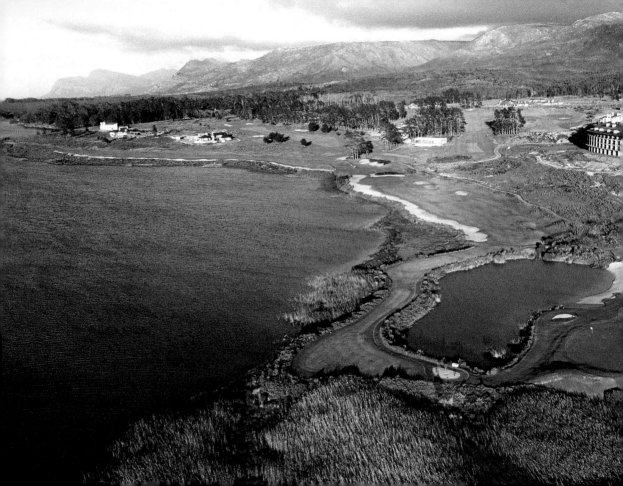

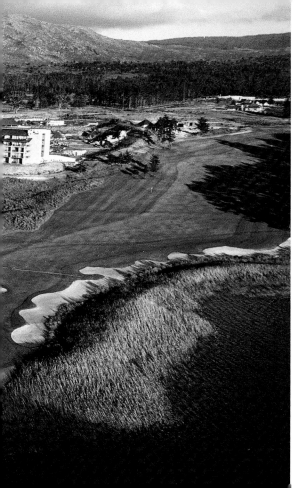

ARABELLA COUNTRY ESTATE
AND GOLF COURSE

Teeing off at the Arabella golf course is a stupendously beautiful affair. The 18-hole championship golf course, just over an hour's drive from Cape Town towards Hermanus, lies at the foothills of the Kogelberg Mountains and borders the Bot River lagoon, the largest natural lagoon in southern Africa. The course with its impressive bent grass greens, wide fairways and picture-postcard views from every hole was designed by Peter Matkovich. A prime golfing holiday destination, Cape Town and its surrounds offer lovers of the sport an array of quality facilities, including Erinvale, designed by the famous Gary Player, and Spier, the only golf club in the world with a 19th hole in a wine cellar.

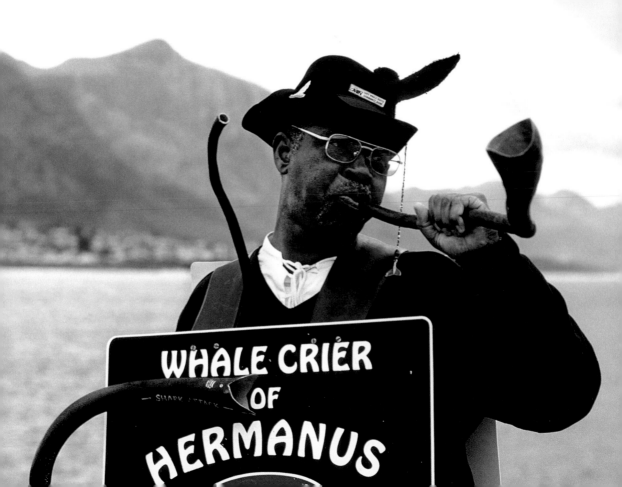

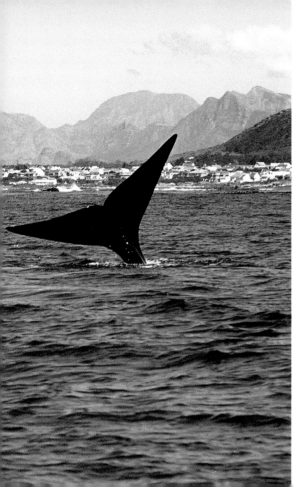

OCEAN TRAVELLERS

At the end of every autumn, southern right whales *(Balaena glacialis)* can be seen cavorting in the sea off Hermanus near the Hemel-en-Aarde Valley. Each year they journey from their feeding-grounds in the Antarctic to the warmer waters of the Cape where they mate, calve and rear their young. In earlier times these whales were regarded as the 'right' kind to hunt: they provided high-quality oil and baleen, were easy to harpoon, and their bodies could be retrieved for processing. Since they were declared a protected species in 1935 their numbers have slowly increased. These whales have no dorsal fins, and individuals can be recognised by the pattern of the callosities (pale patches of roughened skin) on their foreheads and jaws.

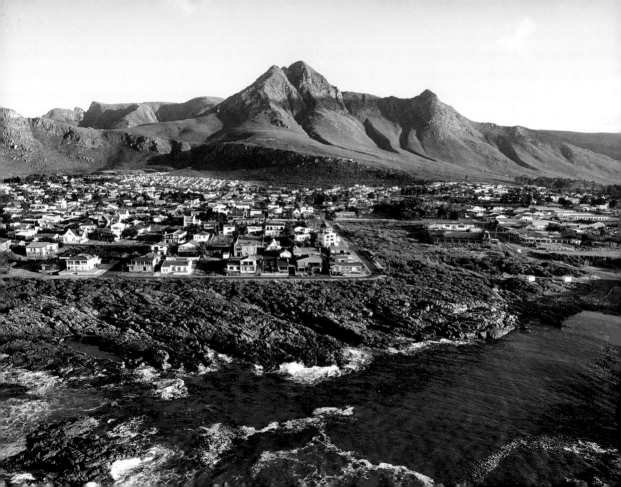

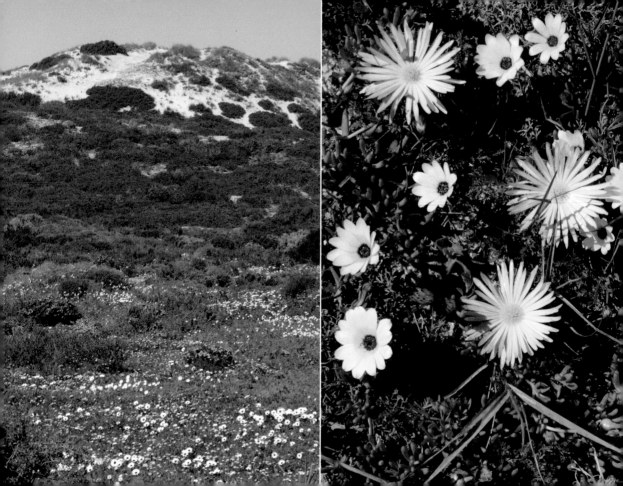

SPRING'S FREE FLOWER SHOW

In a city that has it all, there is no real need for anyone to venture beyond its limits. But for those who can't resist the urge to head out into the blue yonder, a small miracle awaits. In spring, between August and late September, for just a few weeks after the winter rains, a riot of colour erupts along the Cape west coast and in Namaqualand as thousands of flowering plants blanket the landscape. And although it is difficult to predict the exact timing of this floral extravaganza, come the first sunny day in spring, be brave, pack a picnic basket and head for the flowering hills.

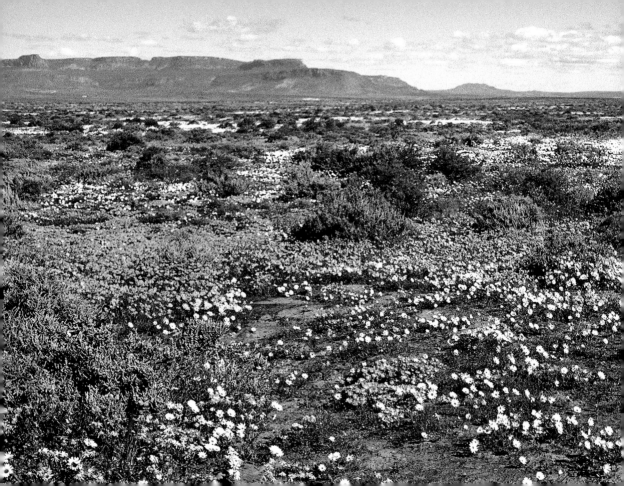

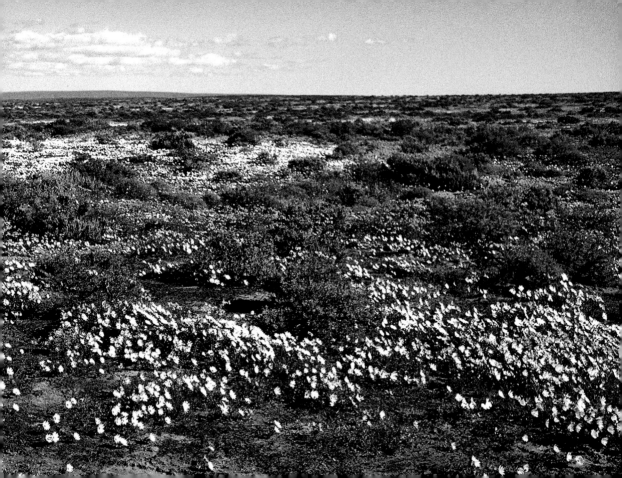

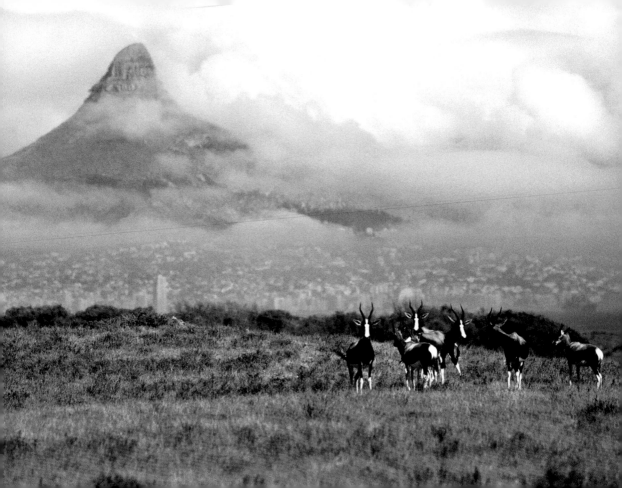

SELECT BIBLIOGRAPHY

Brock, B. B. and B. G. Brock (eds.). *Historical Simon's Town* (Cape Town: Balkema, 1976)

Bulpin, T. V. *Table Mountain and the Cableway* (Cape Town: Book Sales for the Table Mountain Aerial Cableway Co., 1990)

– *Stellenbosch and the Winelands* (Cape Town: Discovering South Africa Productions, 1991)

Burman, J. *Peninsular Profile* (Johannesburg: Nelson, 1963)

– *So High the Road* (Cape Town: Human & Rousseau, 1963)

– *The Cape of Good Intent* (Cape Town: Human & Rousseau, 1969)

– *In the Footsteps of Lady Anne Barnard* (Cape Town: Human & Rousseau, 1990)

Dane, P. *The Great Houses of Constantia* (Cape Town: Don Nelson, 1981)

Deacon, H. (ed.). *The Island: A History of Robben Island, 1488–1990* (Belville: Mayibuye Books, University of the Western Cape, 1996)

De Villiers, S. *A Tale of Three Cities* (Cape Town: Murray & Roberts Buildings (Cape Town) (Pty) Ltd, 1985)

District Six Museum. *The Last Days of District Six: Photographs by Jan Greshoff* (Cape Town: District Six Museum, 1996) (catalogue)

Elphick, R. and H. Giliomee (eds.). *The Shaping of South African Society, 1652–1840* (Cape Town: Maskew Miller Longman, 1989)

Fransen, H. *Groot Constantia. Its History and a Description of its Architecture and Collection* (Cape Town: South African Cultural History Museum, 1983; 3rd edn)

Fransen, H. and M. S. Cook. *The Old Buildings of the Cape* (Cape Town: Balkema, 1980)

Fraser, M. and L. McMahon. *Between Two Shores: Flora and Fauna of the Cape of Good Hope* (Cape Town: David Philip, 1994)

Ginn, P. J., W. G. McIlleron and P. le S. Milstein. *The Complete Book of Southern African Birds* (Cape Town: Struik Winchester, 1990)

Historical Society of Cape Town. *The Josephine Mill* (Cape Town: Historical Society of Cape Town, 1987)

Hurford, E. *The Mount Nelson – In the Grand Tradition* (Cape Town: Millennium Group, 1992)

Jaffer, M. (ed.). *Guide to the Kramats of the Western Cape* (Cape Town: Cape Mazaar Society, 1996)

Kench, J. *Know Table Mountain* (Diep River: Chameleon Press, 1988)

Manuel, G. *District Six* (Cape Town: Longmans Southern Africa, 1967)

National Botanical Institute. *Wild Flowers of South Africa* (Cape Town: Struik, 1996)

Odden, E. and N. Lee. *Cape Point* (Cape Town: Don Nelson, 1984)

Patterson-Jones, C. *Table Mountain Walks* (Cape Town: Struik, 1991)

Phillips, H. *The University of Cape Town, 1918–1948* (Cape Town: University of Cape Town in association with UCT Press, 1993)

Picton-Seymour, D. *Victorian Buildings in South Africa* (Cape Town: Balkema, 1977)

Platter, J. *South African Wines – 1997* (Stellenbosch: John and Erica Platter, 1997)

Rosenthal, E. *Tankards and Traditions* (Cape Town: Howard Timmins, 1961)

– *Fish Horns and Hansom Cabs* (Johannesburg: Donker, 1977)

Schoeman, C. *District Six: The Spirit of Kanala* (Cape Town: Human & Rousseau, 1994)

Smith, M. and P. Heemstra (eds.). *Smith's Sea Fishes* (Johannesburg: Macmillan South Africa, 1986)

Smithers, R. H. N. *The Mammals of the Southern African Subregion* (Pretoria: University of Pretoria, 1983)

Turner, M. *Shipwrecks and Salvage in South Africa* (Cape Town: Struik, 1988)

Veitch, N. *Waterfront and Harbour* (Cape Town: Human & Rousseau, 1994)

Vogts, M. *South Africa's Proteaceae* (Cape Town: Struik, 1982)

Watson, S. *Return of the Moon. Versions from the /Xam* (Cape Town: The Carrefour Press, 1991)

INDEX

Adderley Street 49, 57, **61**, 61
 Flower sellers **61**, 61
 Trafalgar Place 61
Arabella Country Estate and Golf Course
232–233, 233
Art 51
 William Fehr collection 65
Atlantic seaboard 9, 13, 17, **96–97**, 105

Beaches **92–93**
 Boulders 129, **130**
 Camps Bay 99
 Clifton **100–101**, **102–103**, 103, 104
 Diaz 134, 135
 Noordhoek **116–117**, 117
Birds, African penguin (*Spheniscus demersus*) **128–129**, 129,
130, 131
 Cape eagle owl (*Bubo capensis*) **118–119**, 119
 Kelp gull (*Larus dominicanus*) 132
 Lesser doublecollared sunbird (*Nectarinia chalybea*)
194, 194
 Lesser flamingo (*Phoeniconaias minor*) **156–157**, 157

 Orangebreasted sunbird (*Nectarinia violacea*) **195**, 195
 White pelican (*Pelecanus onocrotalus*) **158**, 159
 White-breasted cormorant (*Phalacrocorax carbo*) **159**, 159
Black Consciousness 69
Bloubergstrand 73, **74–75**, 76, 77, **94–95**, 95, **140–141**
Bo-Kaap **182**, 183, 183

Cableway 9, **78**, **79**, 79, **80**
Camps Bay **98–99**, 99, 107, 121
Cape Agulhas 9, 123
Cape of Good Hope 135, 139
Cape Peninsula 121
Cape Point 9, 113, **122**, **123**, 123, 135
Cape Point Peak 125, 135
Cape Town Castle **62–63**, 63, **64–65**, 65
Cape Town Harbour **14–15**, 16, 17, **34–35**
 Alfred Basin 17, 23, 29
 Duncan dock 17
 Victoria Basin 17, 23
Cape Town International Convention Centre **18–19**, 19
Cecilia Forest **204**, 204
Chapman's Peak Drive 9, **114–115**, 115

City centre 10, 12
City Hall 58–59, 59, 60
Clifton 100–101, 102–103, 103, 104, 107
Climate 9
Company's Garden 51, 52–53
 Bell tower 44, 45
 Government Avenue 48–49, 49
 War Memorial 54–55, 55
Crossroads 165

Dassen Island 87, 88–89
De Grendel 220–221
De Waal Drive 206
Democracy 46, 47
 Bill of Rights 47
 Elections 47
District Six 166–167, 167, 168–169, 170–171, 172–173
 Hanover Street 174, 174
Dutch East India Company 65

Entertainment, Jazz 25
 Rock concerts 186–187, 187

False Bay 153
Festivals, Cape Carnival 184–185, 185

Jazzathon 25
 Sunsetter Festival 25
Fishing industry, District Six 172–173, 173, 174, 174, 175, 175
 Trek fishing 148, 149, 150, 151
Flora 193
 Coastal fynbos 138–139, 139
 Cycads 196–197, 197
 King protea (*Protea cynaroides*) 199, 199
 Reed strelitzia (*Strelitzia juncea*) 137, 137
 Scarlet ribbon pincushion (*Leucospermum hybrid*)
 200–201, 201
 Silver tree (*Leucadendron argenteum*) 199
 Wild flowers 140–141, 238, 239, 240–241
Franschhoek 225

Grand Parade 59, 61
Greenmarket Square 59
Groot Constantia 214–215, 215, 216–217, 217, 218
Guguletu 164

Helshoogte Pass 226–227, 227
Hermanus 234, 235, 236, 237
Hotels, Cellars-Hohenhort 212–213, 213
 The Mount Nelson 44–45, 45
Houses of Parliament 56–57, 57

Hout Bay 99, 107, 112, 113, 113, 121, 154

Informal economy 160, 161, 161, 162, 163

Josephine Mill **205**, 205

Kalk Bay 153

Kathrada, Ahmed 69

Khayelitsha 161, 162, 163

Kirstenbosch National Botanical Garden 113, **186–187**, 187, **188–189**, 189, **190**, 190, **191**, 191, **192–193**, 193, **196–197**, 197

Lighthouses, Cape Point 123, **124**, 125, **127**, 127

 Dassen Island 132

 Green Point **86**, **87**, 87

 Roman Rock 146–147, 147

Long Street 176–177, 177, **178**, 178, **179**, 179

 Baths 180–181, 181

Mammals, Bontebok (*Damaliscus dorcas*) 242

 Cape fur seal (*Arctocephalus pusillus pusillus*) 42, 43, 143

 Chacma baboon (*Papio hamadryas ursinus*) 136, 136

 Rock hyrax (*Procavia johnstoni*) **82–83**, 83

 Southern right whales (*Balaena glacialis*) **235**, 235

Mandela, Nelson 59, 69

Map 8

Marine life, Clown triggerfish (*Balistoides conspicillum*) 41

 Giant moray eel (*Gymnothorax javanicus*) 40

 Giant spider crab (*Macrocheira kaempferi*) 40

 Semicircle angelfish (*Pomacanthus semicirculatus*) 40

 Western clownfish (*Amphiprion ocellaris*) 40

Mbeki, Govan 69

Mostert's Mill **207**, 207

Mountains, Devil's Peak 9, 12, **14–15**

 Lion's Head 9, **96–97**, 97, **106**, 107, 242

 Sentinel 112

 Table Mountain 9, 12, **34–35**, **72–73**, 73, **74–75**, 76, 77, 78, 79, **81**, 83, **94–95**, 95, 113

 Twelve Apostles 9, **98–99**, 99

Museums, Castle Military Museum 65

Namaqualand 239

Neethlingshof **230–231**, 231

Newlands rugby stadium **202–203**, 203

Oceans, Atlantic 9, **13**, **89–91**, 99, 123

 Indian 9, 123

Oudekraal **106–107**, 107

 Coral Gardens 121

Restaurants, Harbour Cafe 29

Rhodes Memorial **210–211**, 211
Rhodes, Cecil John 190, 211
Robben Island **66–67**, 67, **68–69**, 69, **70–71**, 107, 129

Sea Point **96–97**, 97
Shebeens 164
Shipwrecks, *Lusitania* 123
Shopping **22–23**, 23, 177
 Crafts and curios **108**, **109**, 109, **110–111**
Signal Hill 9, 12, **84–85**, 85, **96**, 97
 Noon Gun 85
Simon's Town **142**, **144–145**, 145, **146–147**, 147
Sisulu, Walter 69
South African National Gallery **50–51**, 51
South African War 45
Sports, Golf 233
 Rugby **202–203**, 203
 Surfing 155
St James **152–153**, 153
Statues, General Louis Botha 47, 47
 Just Nuisance 144
Stellenbosch **228–229**, 229

Table Bay 17, 23
Two Oceans Aquarium 23, **36–37**, 37, 40, 41

I&J Predator Exhibit **38–39**, 39
Kelp Forest Exhibit **36–37**, 37

University of Cape Town **208–209**, 209

V&A Waterfront 9, 16, 17, **20–21**, 21, **22–23**, 23, **24–25**, 25, **26–27**, 27, **28–29**, 29, **30–31**, **100–101**
 Clock Tower 5, 29, **32–33**, 33
 Marina 27
 Old Port Captain's Office Building **28**, 29
 Waterfront Village **26–27**, 27
Van der Stel, Simon 145, 215, 229
Van Riebeeck, Jan 49, 63, 113, 190

West Coast **240–241**
Western seaboard **120–121**, 121
Winelands **218–219**, 219, **222–223**, 223, **224–225**, 225, **226–227**, **228–229**, **230–231**

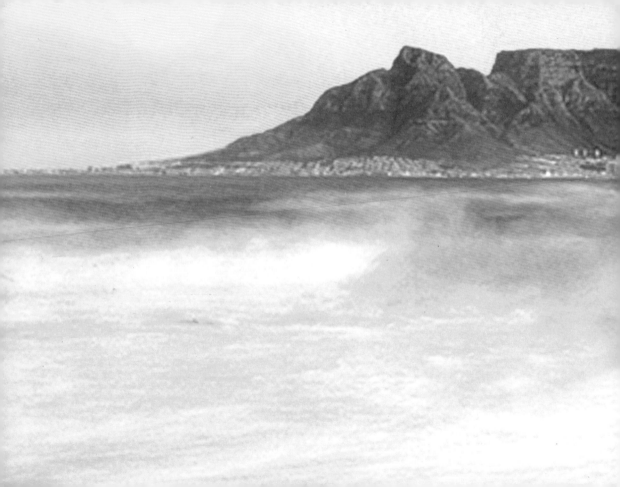